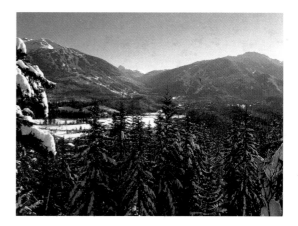

WHISTLER

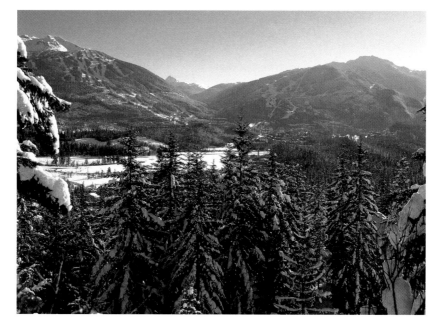

whitecap

Text by Tanya Lloyd Kyi
Edited by Elaine Jones
Proofread by Lisa Collins
Cover and interior design by Steve Penner
Cover layout by Jacqui Thomas

Printed and bound in China by WKT Company Limited.

Library and Archives Canada Cataloguing in Publication

Kyi, Tanya Lloyd, 1973–
 Whistler
 (Canada series)
(hardcover)—
 ISBN 1-55110-857-7
 ISBN 978-1-55110-857-5
(paperback)—
 ISBN 1-55285-785-9
 ISBN 978-1-55285-785-4

1. Whistler (B.C.)—Pictorial works. I. Title.
FC 3849.W49L66 1999 971.1'31 C98-911022-2
F1089.5.W49L66 1999

The publisher acknowledges the financial support of the Government of Canada
through the Book Publishing Industry Development Program for our publishing
activities.

For more information on the Canada series and other titles by Whitecap Books,
please visit our website at www.whitecap.ca.

Whistler strikes a balance between recreation and relaxation that draws a million visitors a year to the alpine region north of Vancouver, British Columbia. From extreme skiing on the slopes of Blackcomb to a day at the Chateau Whistler's spa, the resort can cater to every whim.

Since the early twentieth century, when passengers on the Canadian Pacific Railway could book a week-long fishing vacation at Rainbow Lodge for two dollars, the Whistler region has been drawing adventure-seekers. While skiing and snowboarding dominate the winter, summer brings windsurfing, rafting, sailing, and mountain biking. None of these appeal? Hit the slopes again, even in July. Blackcomb is the only mountain in North America to offer lifts to year-round skiing. The Hortsman Glacier boasts 45 hectares of prime conditions.

Whistler will host the Nordic, alpine, and skiing events for the Vancouver 2010 Olympic and Paralympic Winter Games. New facilities will accommodate bobsleigh, luge, skeleton, biathlon, cross-country skiing, and sledge ice hockey. The Athlete's Village for the Games will take shape at the south end of Whistler. Efforts are being made to reduce the environmental impact of this construction boom so that residents and visitors alike can continue to enjoy the area's spectacular scenery and wildlife.

Whatever activity you choose, you'll soon find yourself immersed in Whistler Village's easygoing atmosphere. Lively music from an outdoor café will pull you in, and before you know it, you'll be taste-testing in one of more than a hundred bars and restaurants, shopping in an up-scale boutique, or chatting up the local snowboarders at the base of the gondola. Whistler was designed as a resort destination—it's impossible not to have fun.

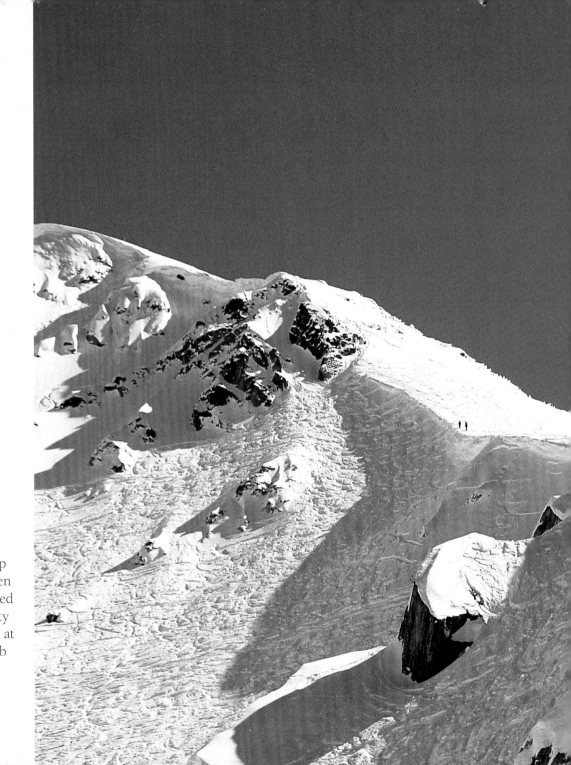

Breathtakingly steep drops challenge even the most experienced skiers. About twenty percent of the runs at Whistler/Blackcomb are designed for experts.

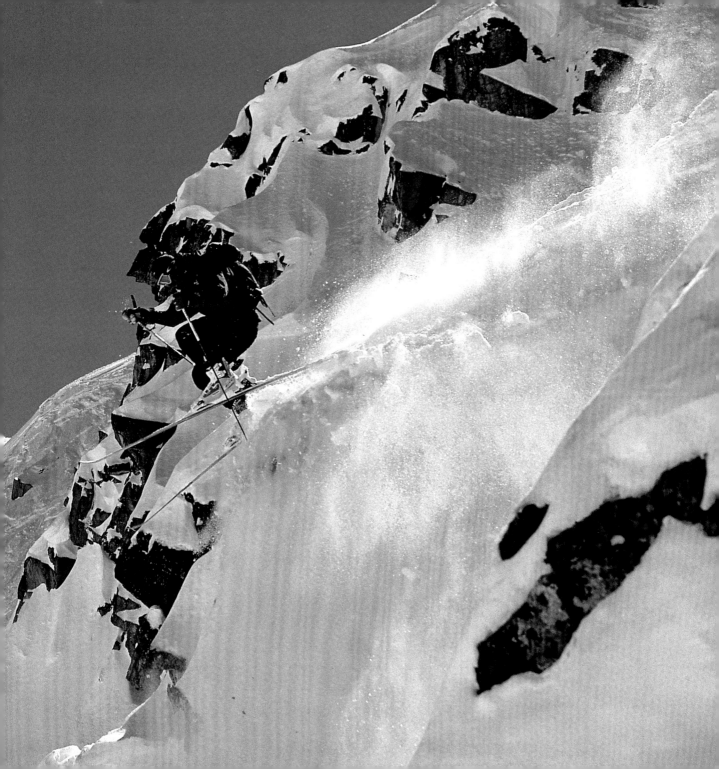

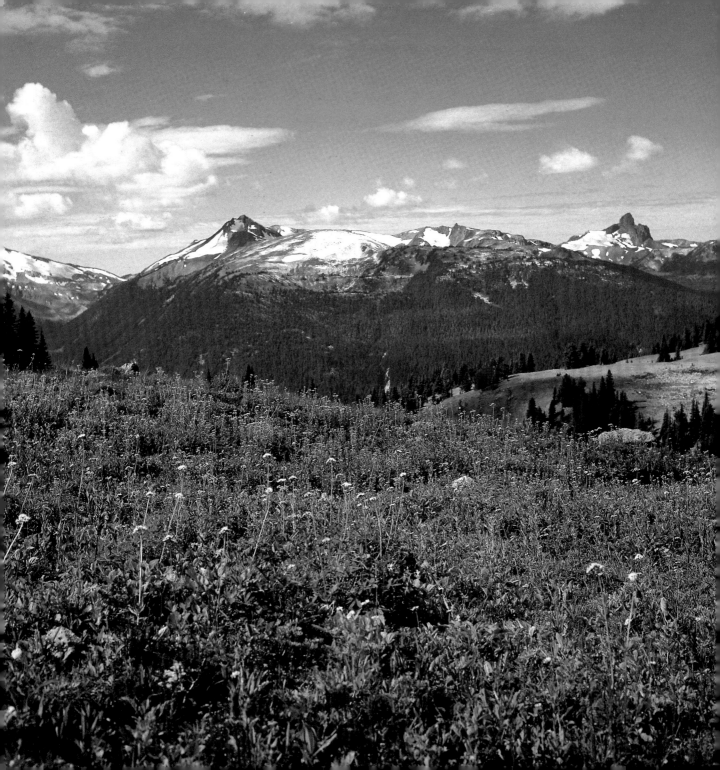

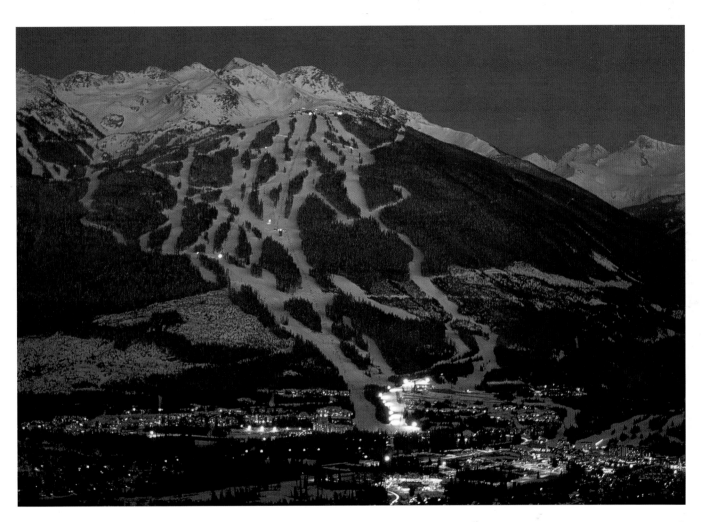

Blackcomb and Whistler have the highest vertical rises of any ski mountains in North America. Whistler rises 1,530 metres and Blackcomb 1,609 metres—one vertical mile.

Wildflowers cloak the alpine meadows throughout late spring and summer, creating a destination for hikers and a grazing area for deer, black bears, and marmots.

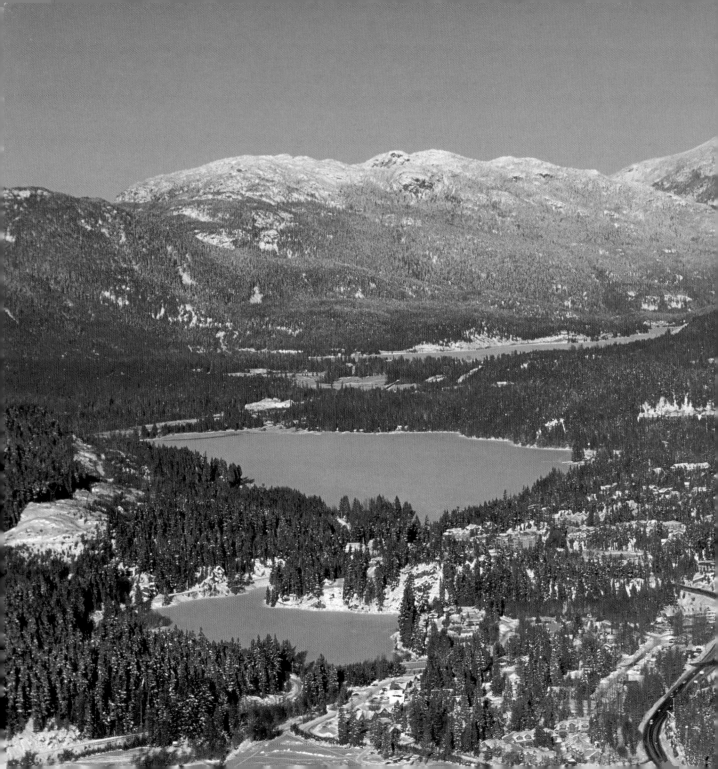

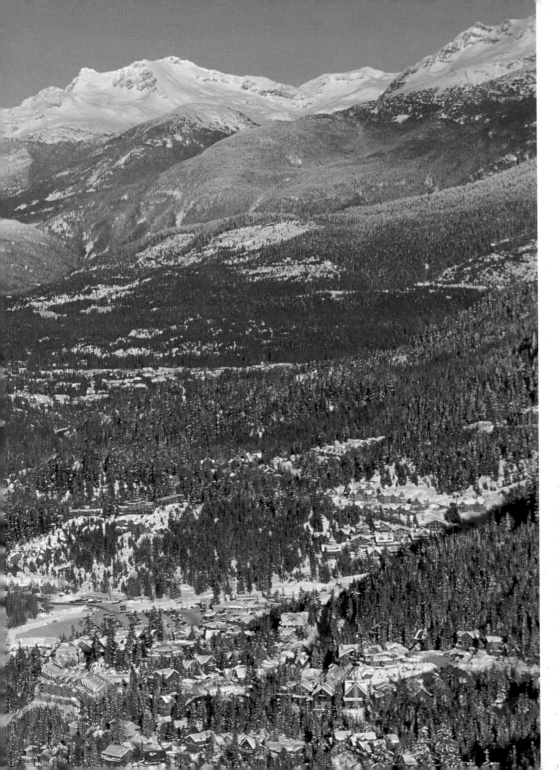

Whistler's reputation as a resort destination began in 1914, when Alex and Myrtle Philip opened Rainbow Lodge, a fishing retreat on the shores of Alta Lake. Other early attractions included the Hillcrest, Cypress, and Jordan lodges.

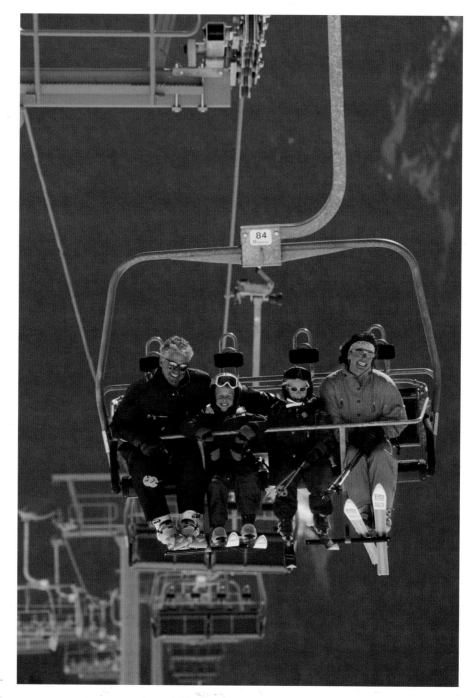

Three gondolas,
12 high-speed quads,
5 triple chairs,
a double chair, and
12 surface lifts speed
visitors up and down
the mountains.

FACING PAGE
Helicopter tours offer
panoramic views of
glaciers, crevasses,
and granite peaks.

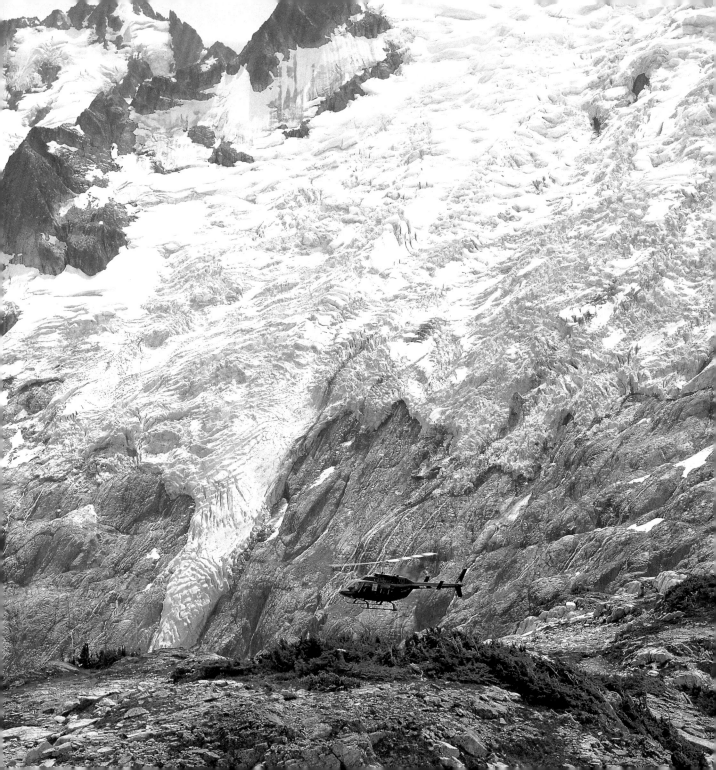

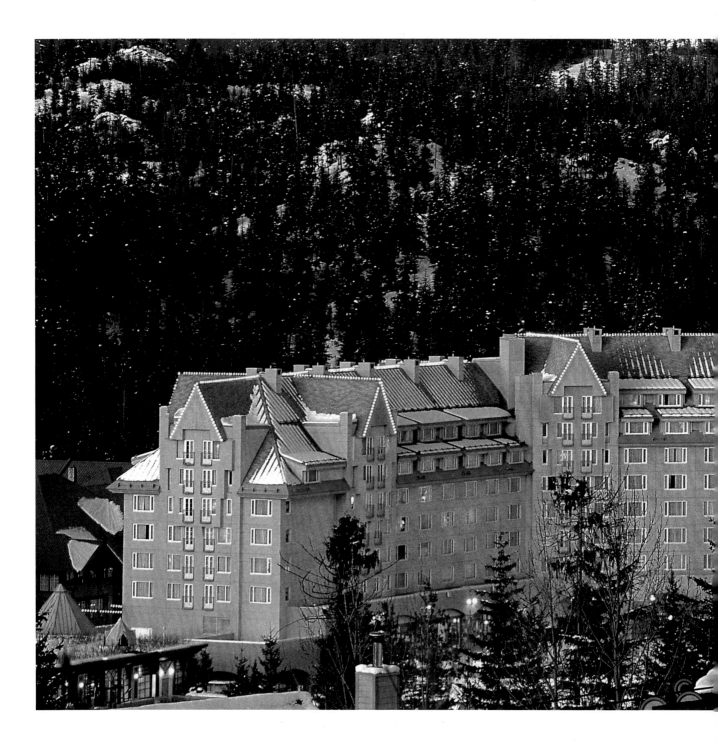

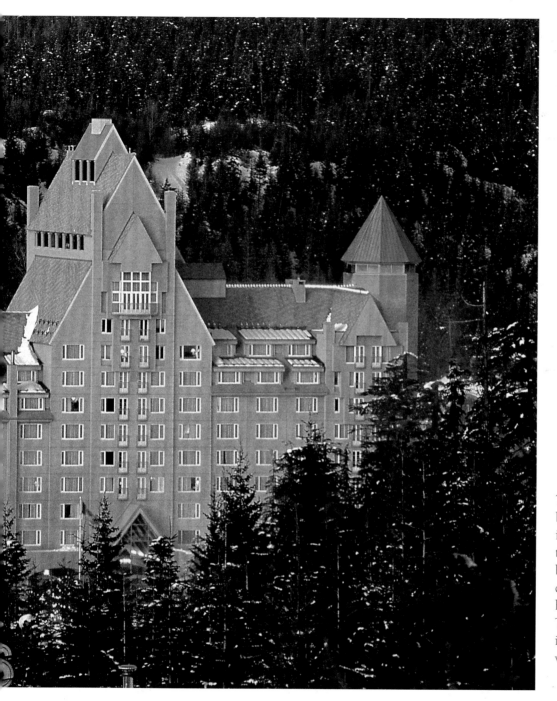

The first hotel built by Canadian Pacific in almost a century, the Chateau Whistler boasts its own golf course, tennis courts, health club, and spa. This luxury hotel is billed as a resort within a resort.

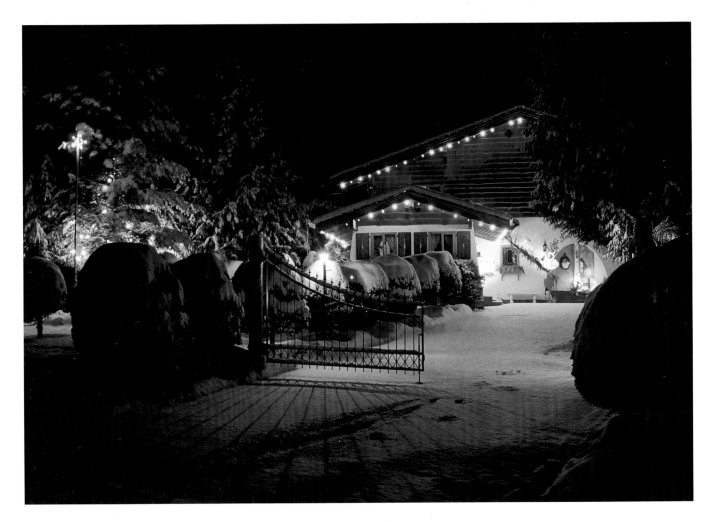

Lit by Christmas lights and surrounded by snowdrifts, Whistler
homes seem to capture the spirit of the season. Skating, tobagganing,
and carolling make Christmas here an unforgettable experience.

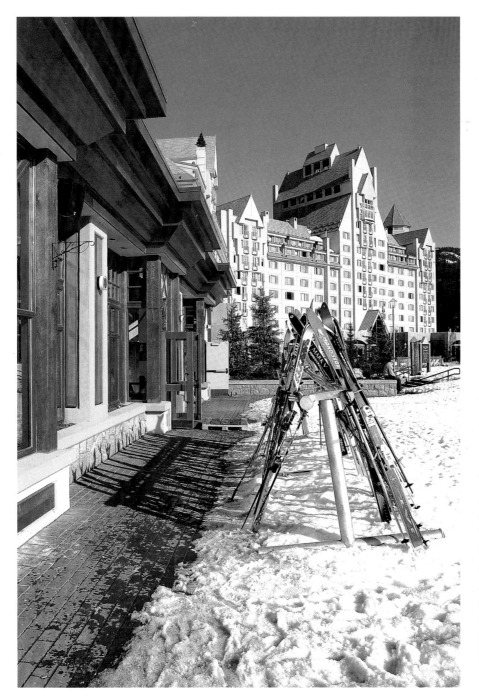

When the Garibaldi Lift Company first opened its doors on Whistler Mountain in 1966, a lift ticket cost five dollars. About 5,000 skiers a day visited in 1974. The lifts can now carry 59,000 people an hour.

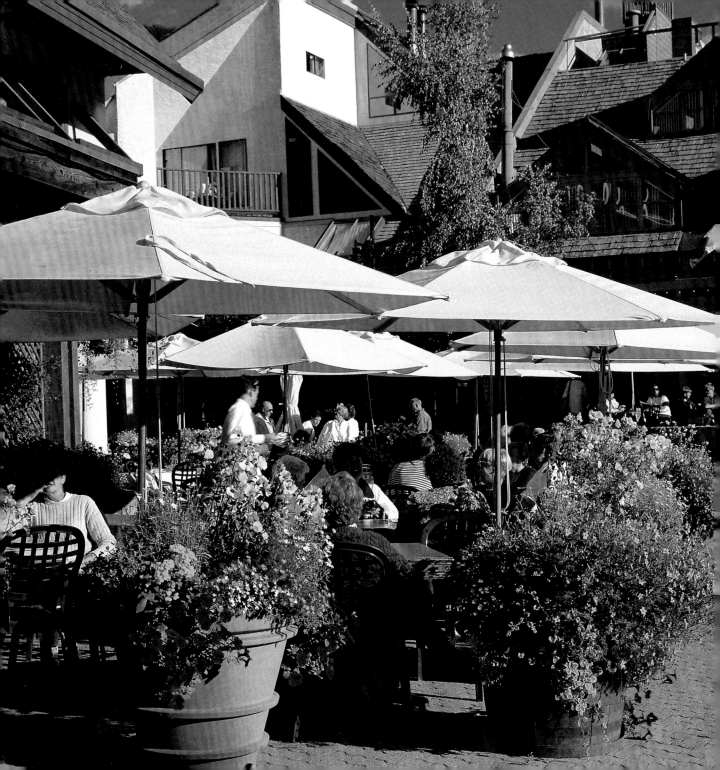

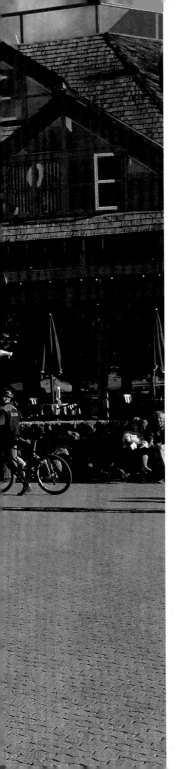

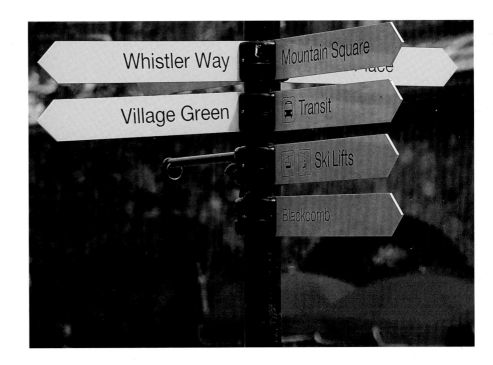

Colourful signs identify pedestrian squares and lanes.

European-style patios and terraces line the village streets. More than a hundred bars and restaurants offer everything from sushi and dim sum to moussaka and satay.

Though Whistler has only about 10,000 full-time residents, there are often more than 45,000 visitors in the village. More than a million people visit each year.

FACING PAGE
The first condominium was built here in 1965. Units sold for under $10,000. The village now has more lodging on the sides of the slopes than any other resort on the continent.

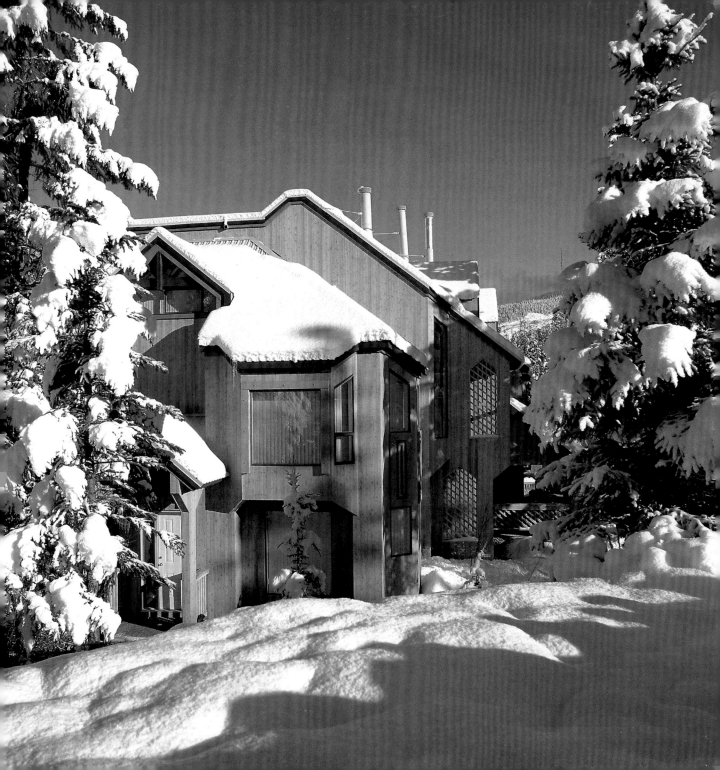

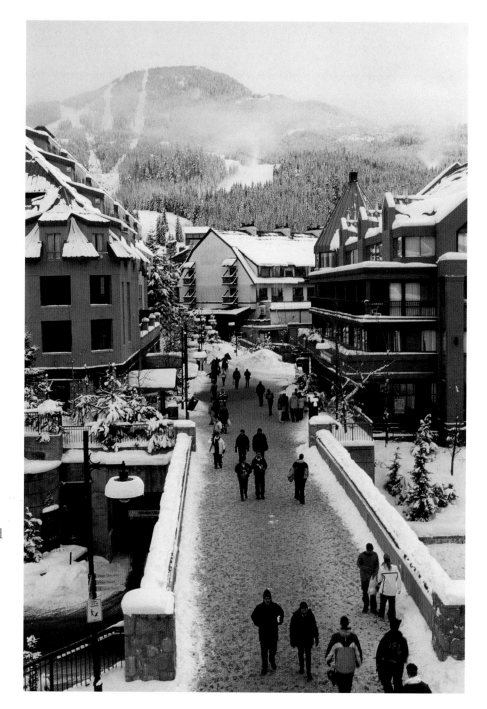

Careful community planning has ensured a cheerful, easygoing atmosphere in the village. Pedestrians can wander freely between shops and restaurants on pedestrian malls.

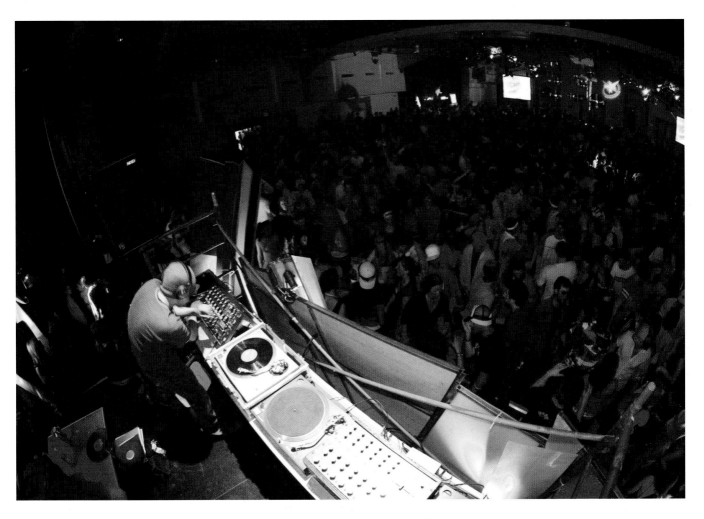

Whistler's bars and nightclubs host DJs or bands every night of the week.

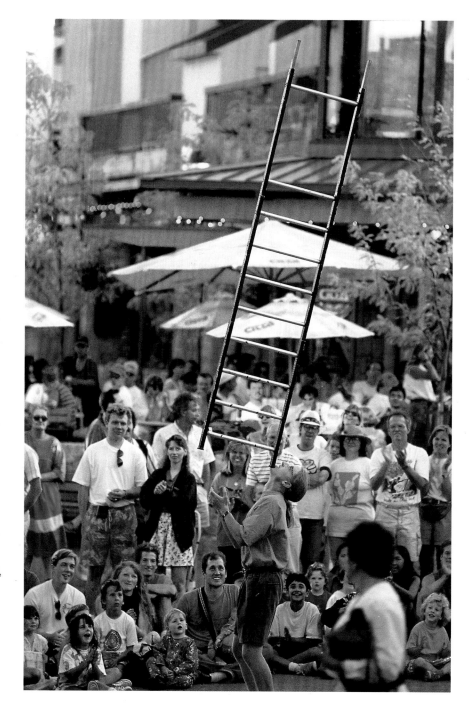

Tourism Whistler organizes street entertainment, such as this balancing act, along with well-known performers and outdoor concerts, to help make the village as enjoyable in the summer as it is during the ski season.

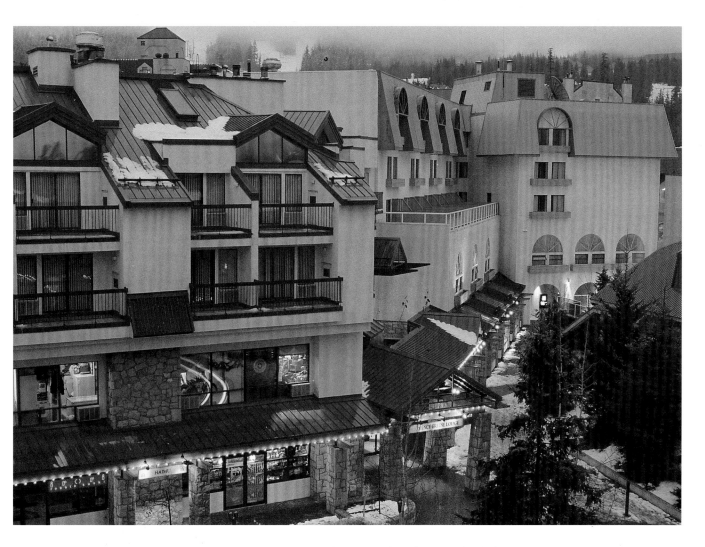

The Crystal Lodge was built by Nancy Greene Raine, Canada's Olympic medal winner and world cup champion, and her husband, Al Raine. Both were prominent figures in the early development and promotion of Whistler.

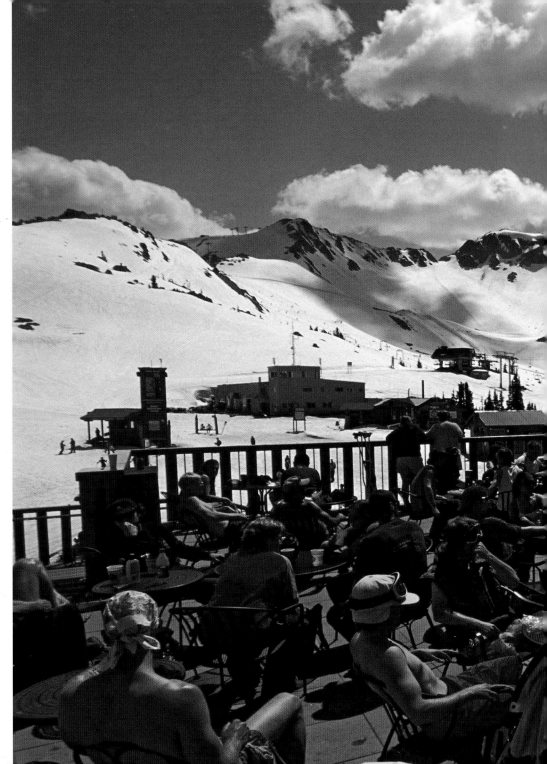

The après-ski crowd keeps shops and restaurants booming.

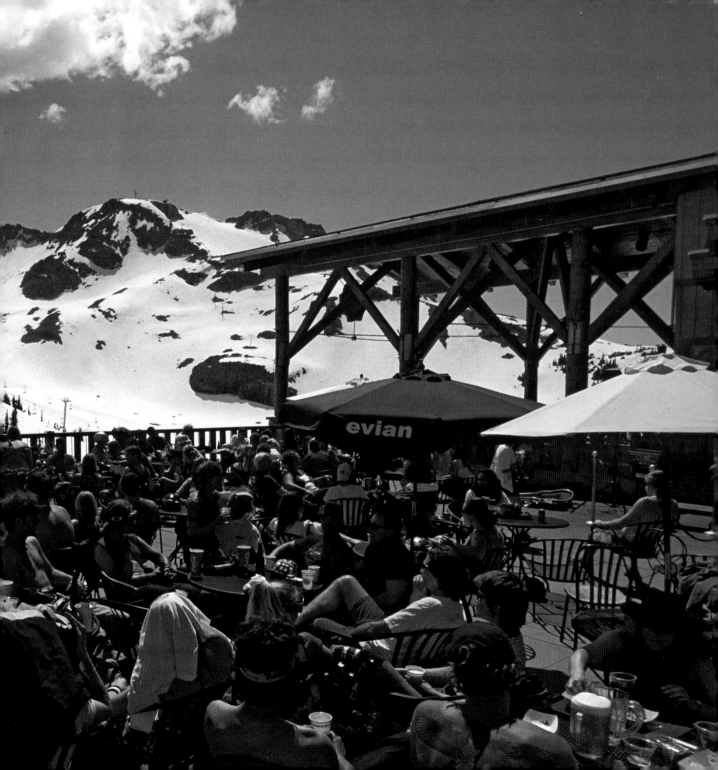

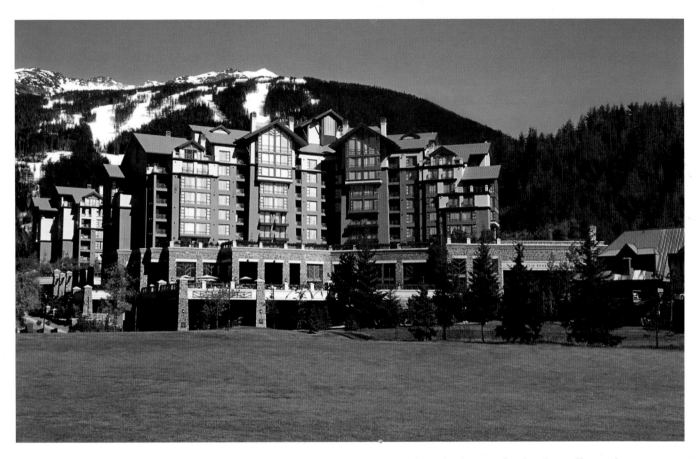

Situated in the heart of Whistler Village, the Westin Resort and Spa is a short walk from the gondolas that serve both Whistler and Blackcomb mountains.

Whistler boasts many great venues for live music and has hosted internationally acclaimed performers such as Nickelback, Justin Timberlake, the Matthew Good Band, Faith Hill, The Tragically Hip, and Black Eyed Peas. Concerts are staged outdoors throughout the year.

The newly reno-
vated Telus Whistler
Conference Centre,
with its massive
ballroom and 19
conference rooms,
can accommodate
up to 2,000 guests.

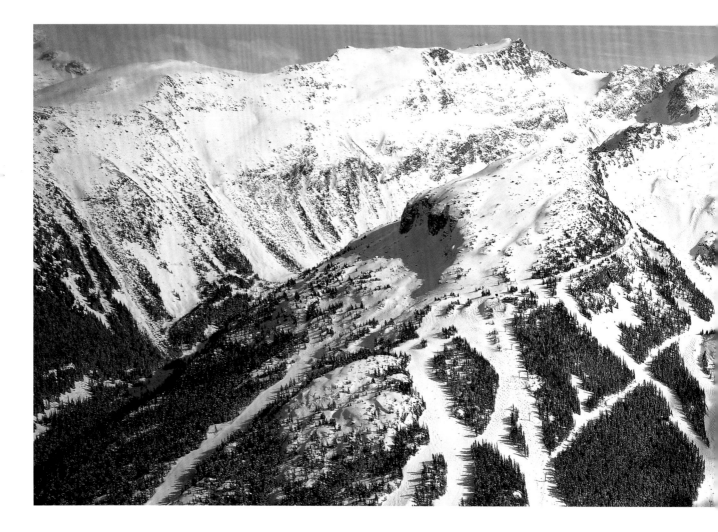

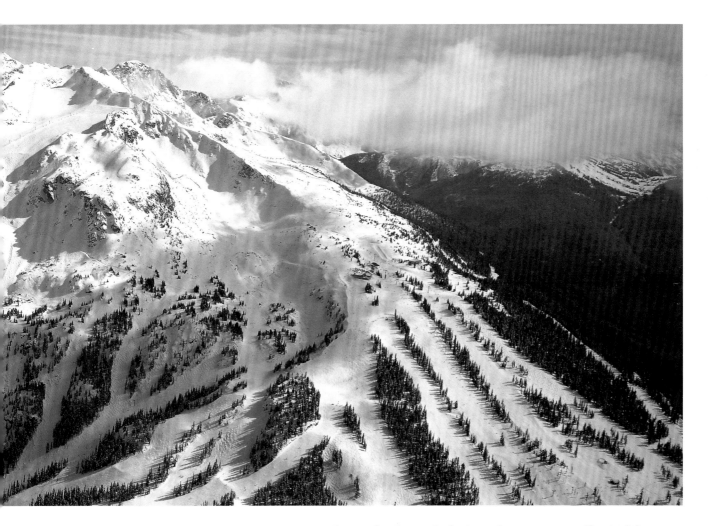

Together, Whistler and Blackcomb mountains offer 33 lifts and 200 ski runs, 3 glaciers, and 12 alpine bowls spread over 3,200 hectares (8,100 acres). The longest runs stretch for 11 kilometres.

Over 900 ski instructors and close to 300 snowboard instructors help make the Whistler/Blackcomb Ski and Snowboard School the largest in Canada. A variety of specialized camps are available, featuring backcountry, snowboarding, and cross-country skiing. Women-only and children's classes are also offered.

High in the mountains, alpine bowls become winter reservoirs of powder.

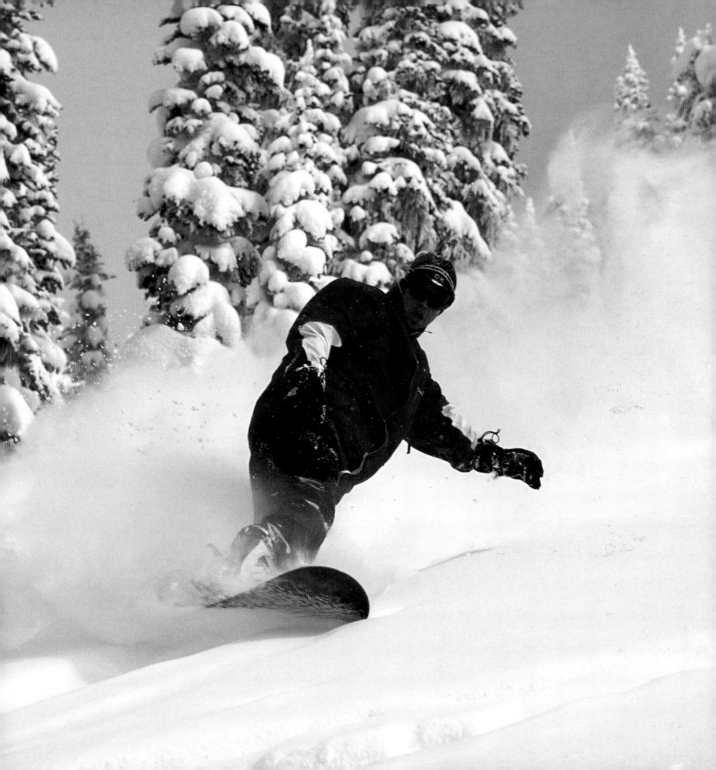

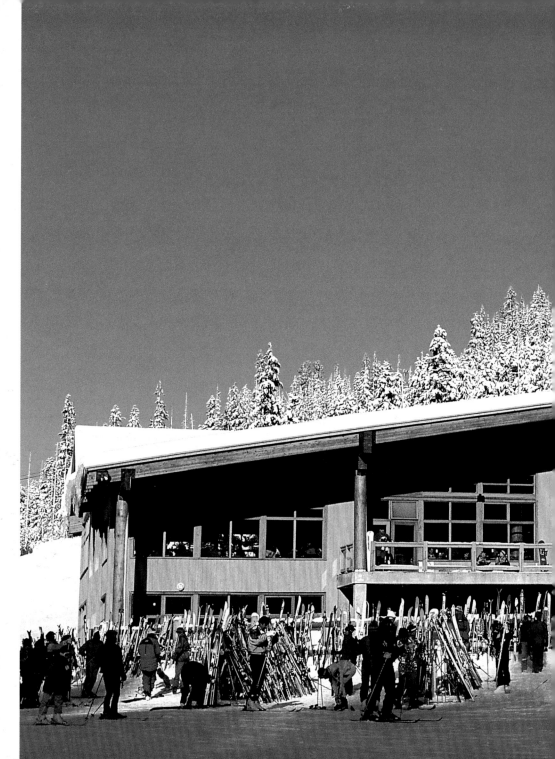

Glacier Creek Lodge
offers a place to rest
knees and enjoy a
warm drink part way
up Blackcomb.

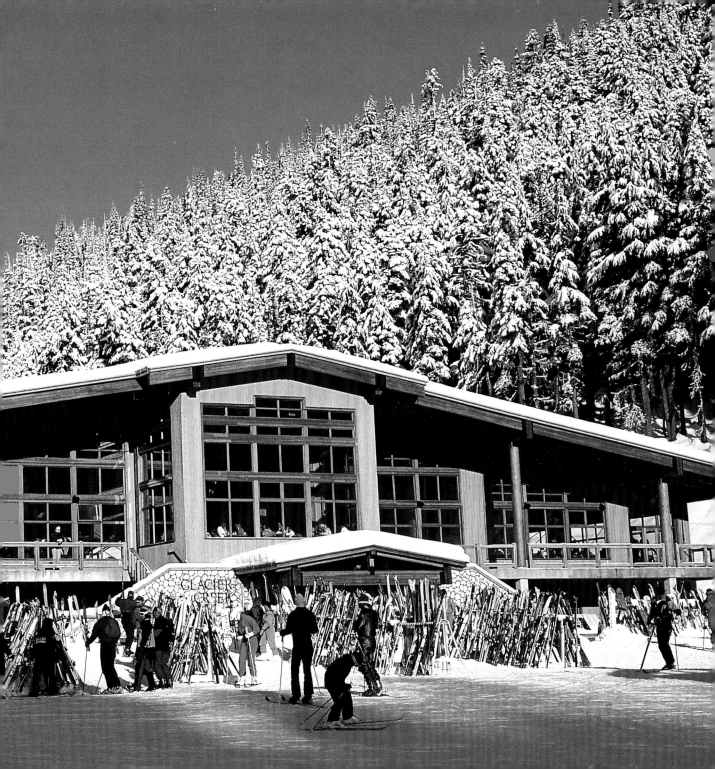

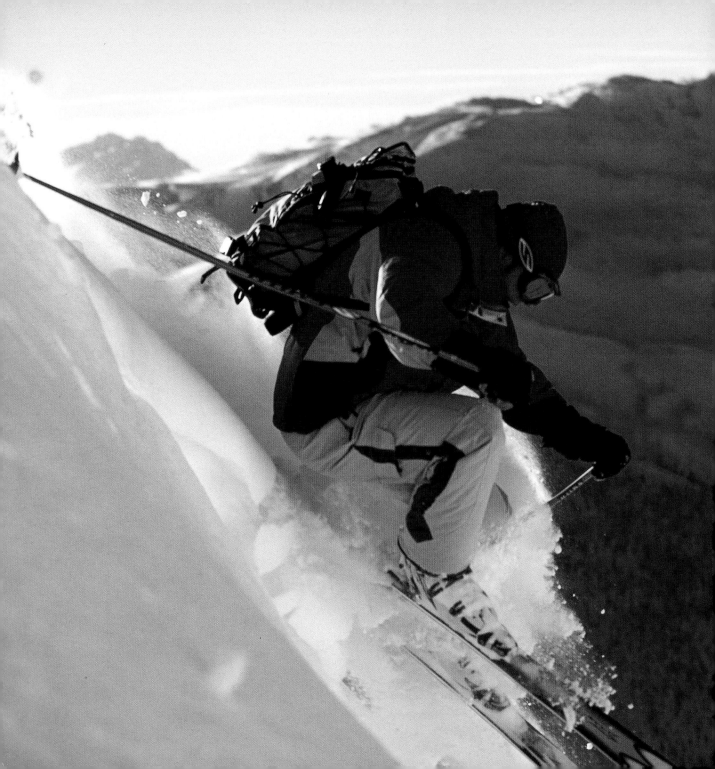

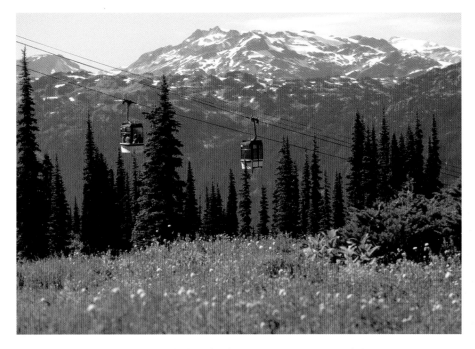

The Whistler express gondola whisks its passengers up the mountain.

High profile skiers to visit the lodge have included
Pierre Trudeau, Prince Charles and his sons William
and Harry, and countless Hollywood stars.

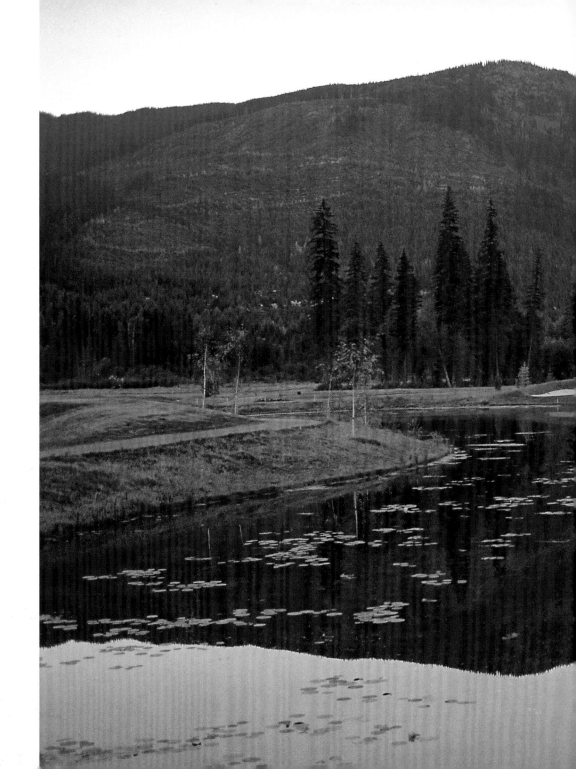

Golf Digest named Nicklaus North Golf Course the best new course in Canada after it opened in 1995.

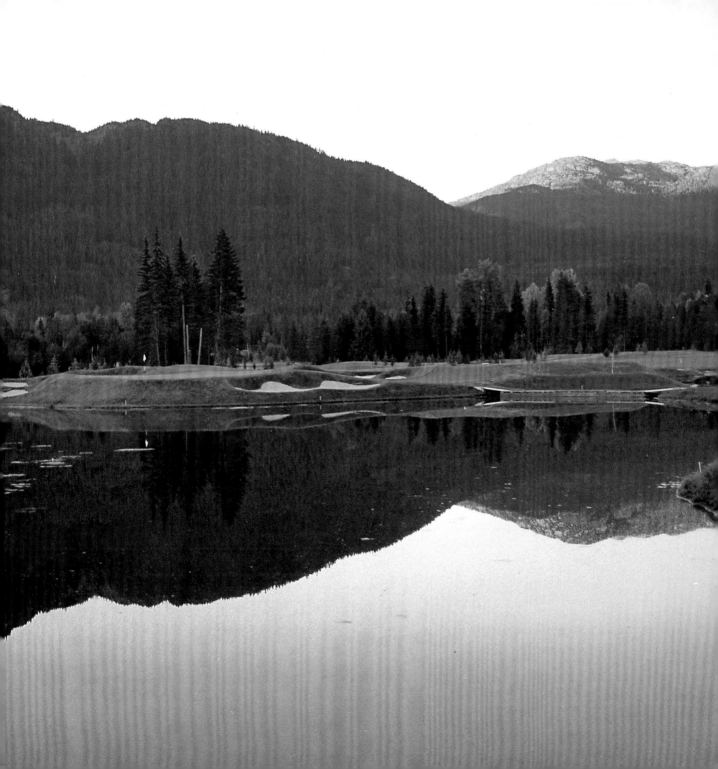

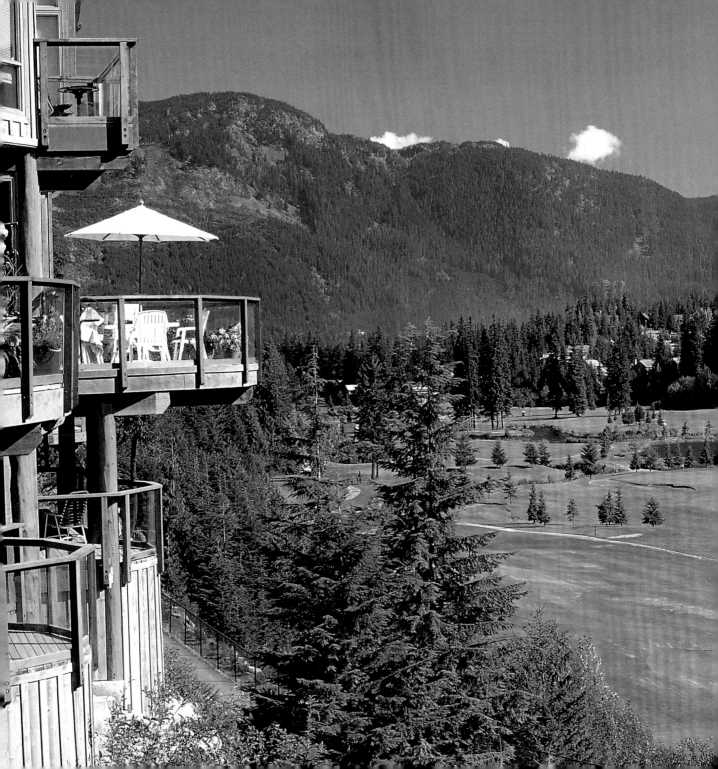

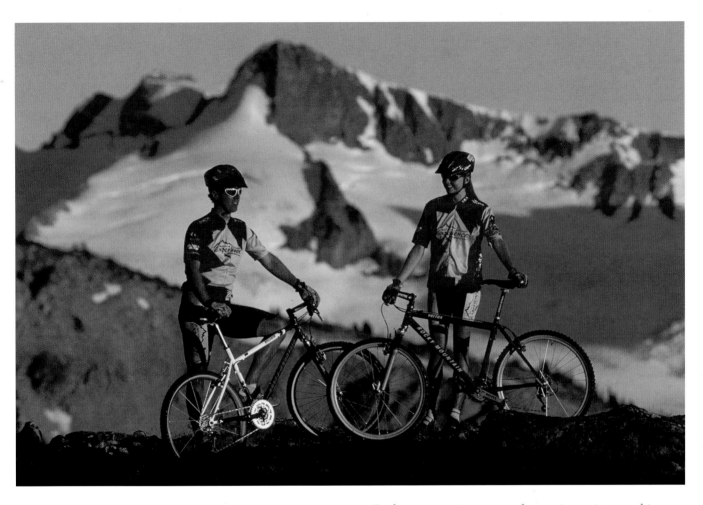

Cyclists can enjoy as much terrain variety as skiers do in winter. A new mountain bike park, regarded as one of the world's best, offers 200 kilometres of trails over 1,200 metres of elevation.

Designed by Arnold Palmer in 1982, Whistler Golf Club is the area's busiest course. Golfers play more than 20,000 rounds a year here.

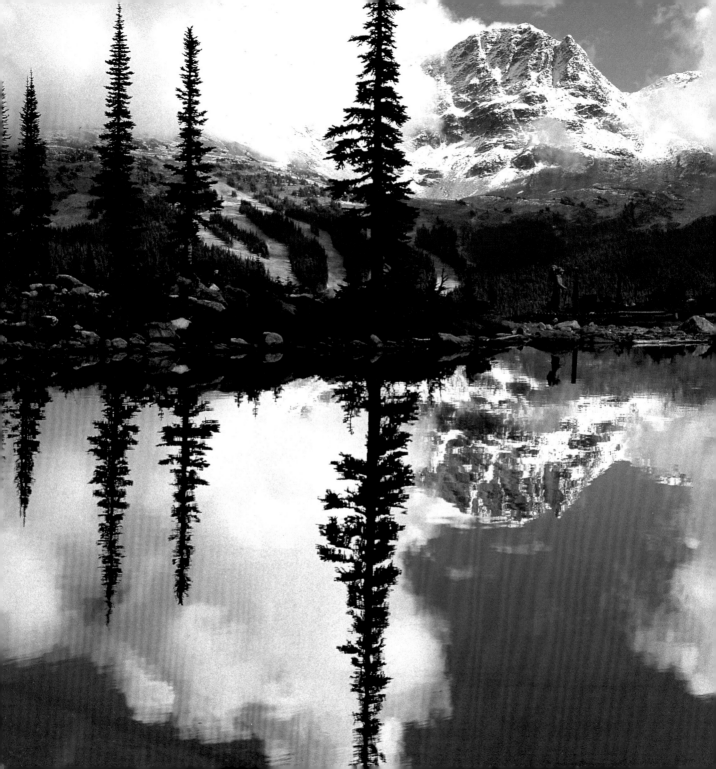

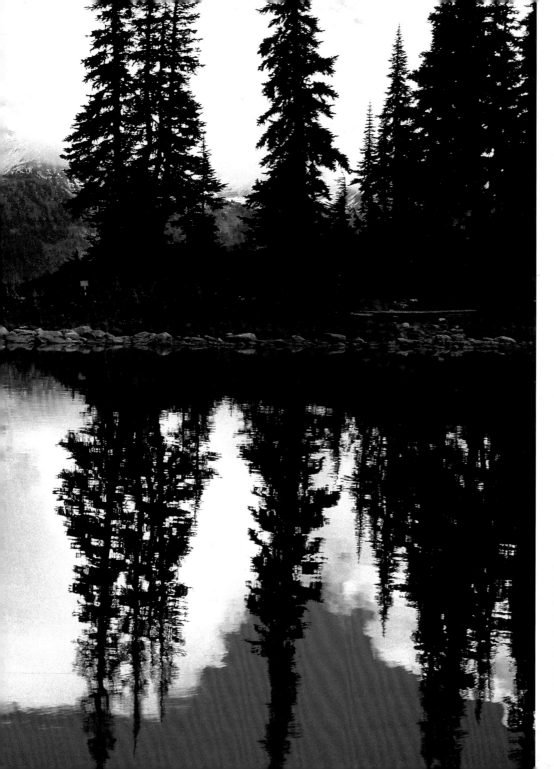

A 3.5-kilometre loop trail above the Village Express Gondola draws hikers to the shores of Harmony Lake. Blackcomb peak is reflected in its waters.

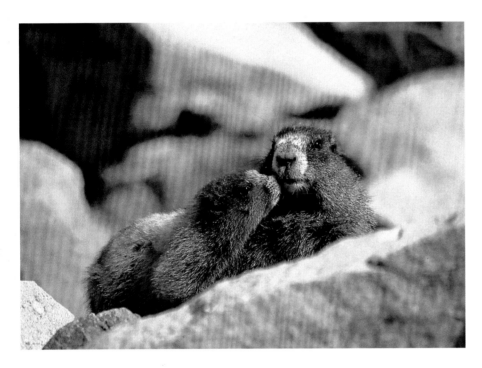

Whistler Mountain is named for the whistling call of the western hoary marmot, a furry inhabitant of the alpine meadows.

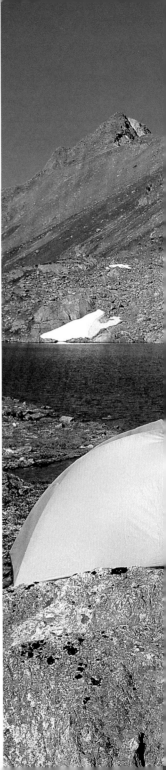

Campers escape civilization at one of the area's isolated alpine lakes.

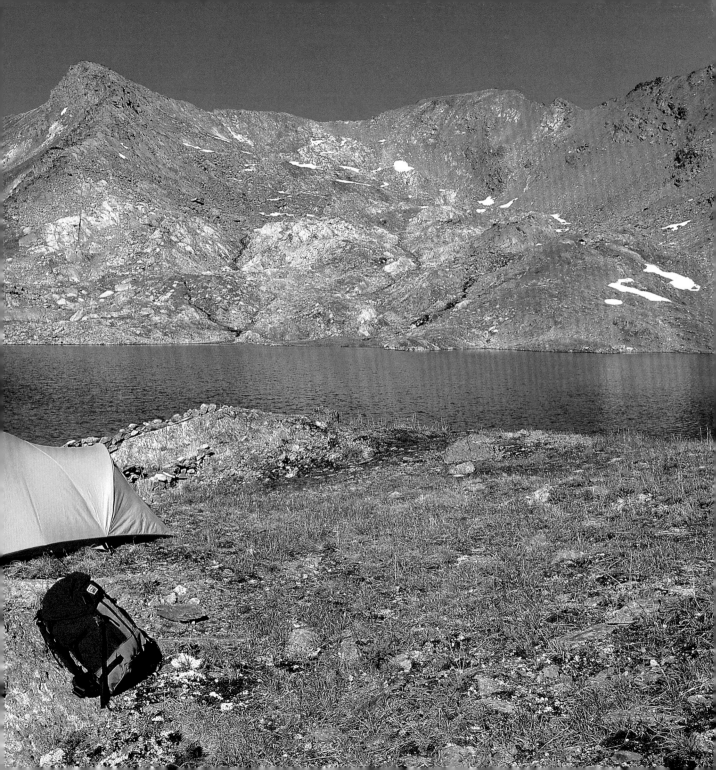

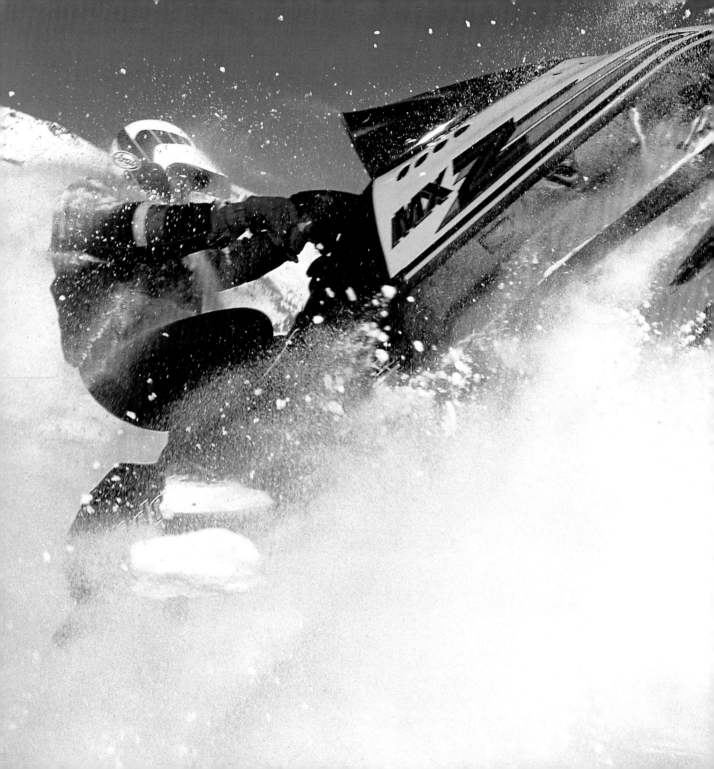

Heavy snowfall makes the area perfect for snow-mobiling. One favourite winter trip is to a natural hot springs north of Pemberton.

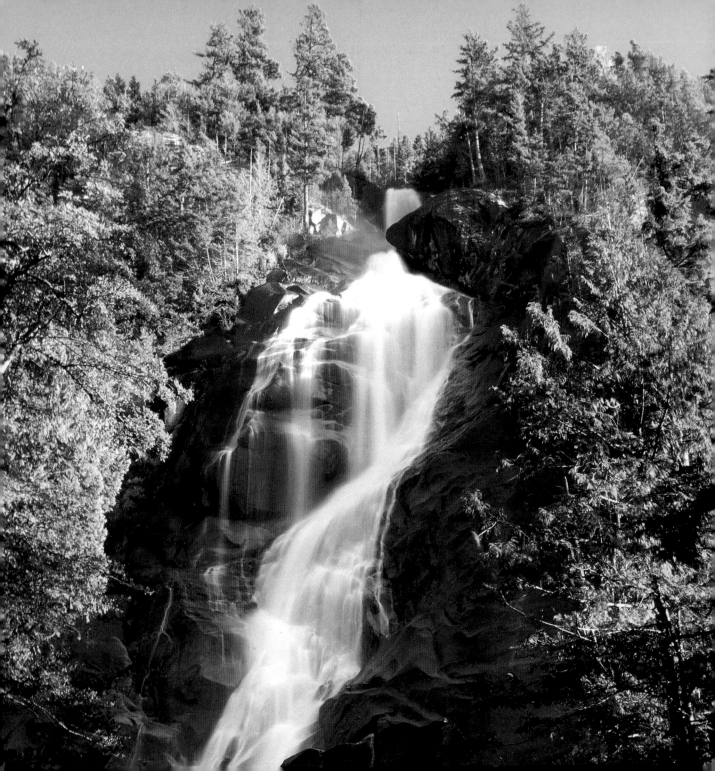

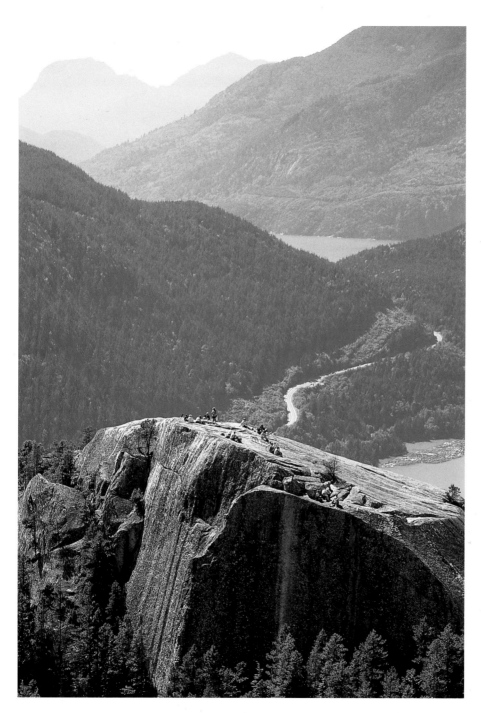

The Stawamus
Chief towers above
Highway 99 and the
town of Squamish
on the route from
Vancouver to
Whistler. The Chief's
560-metre granite
face draws rock
climbers from across
North America.

FACING PAGE
Shannon Falls, just
south of Squamish
and the Stawamus
Chief, drops a spec-
tacular 335 metres.
The surrounding
park provides
motorists with an
excellent rest stop
and picnic area.

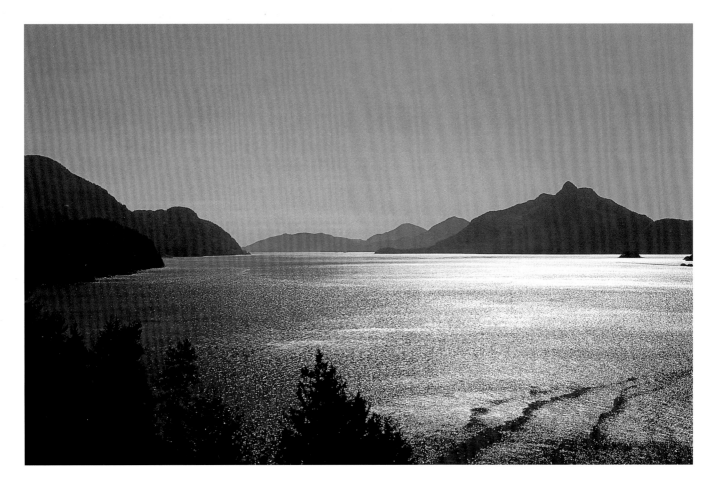

Highway 99, the "Sea to Sky Highway,"
connects the Whistler area to the city of
Vancouver, 120 kilometres to the south, and
gives visitors a panoramic view of Howe Sound.

About eighty percent of the world's heli-skiing takes
place in British Columbia. The sport offers the unique
opportunity to enjoy spectacular snow conditions year-
round on the peaks and glaciers surrounding Whistler.

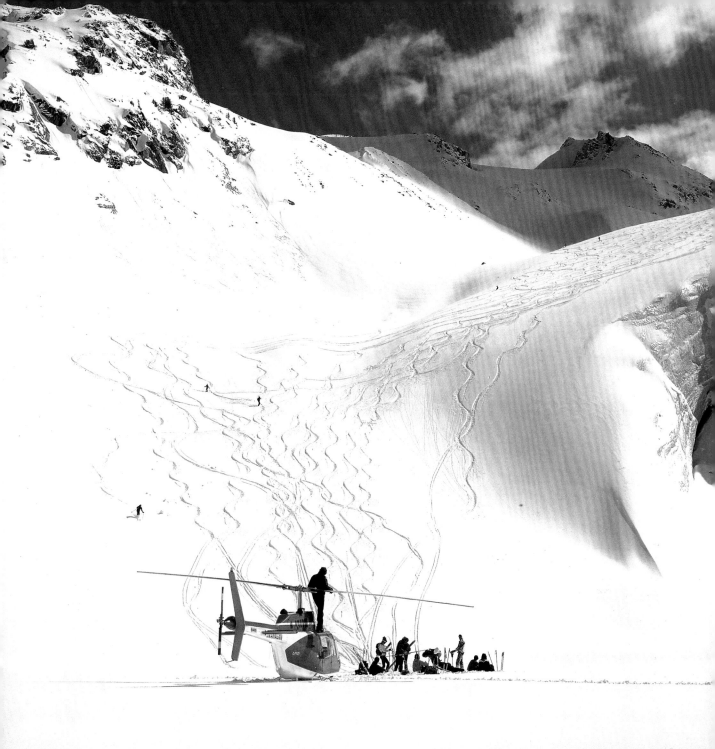

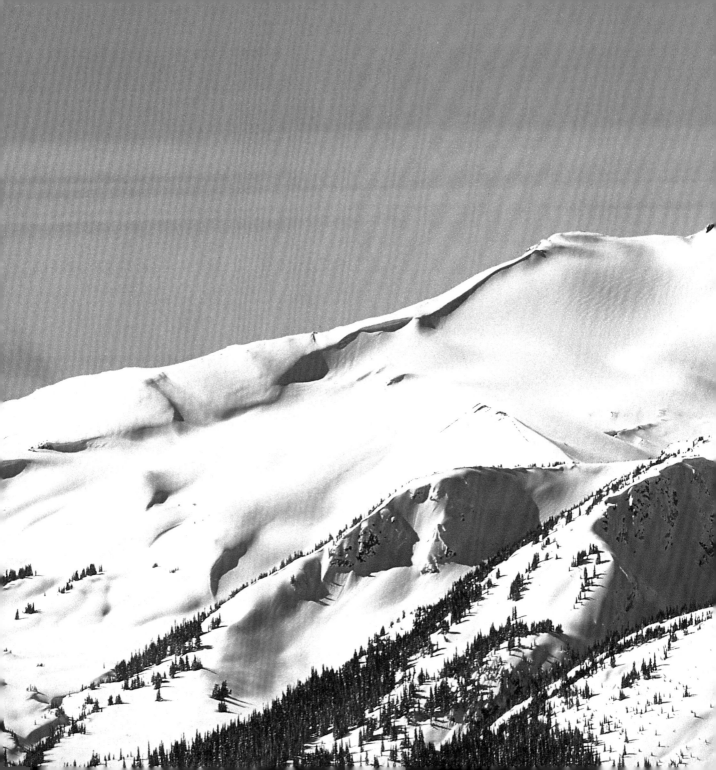

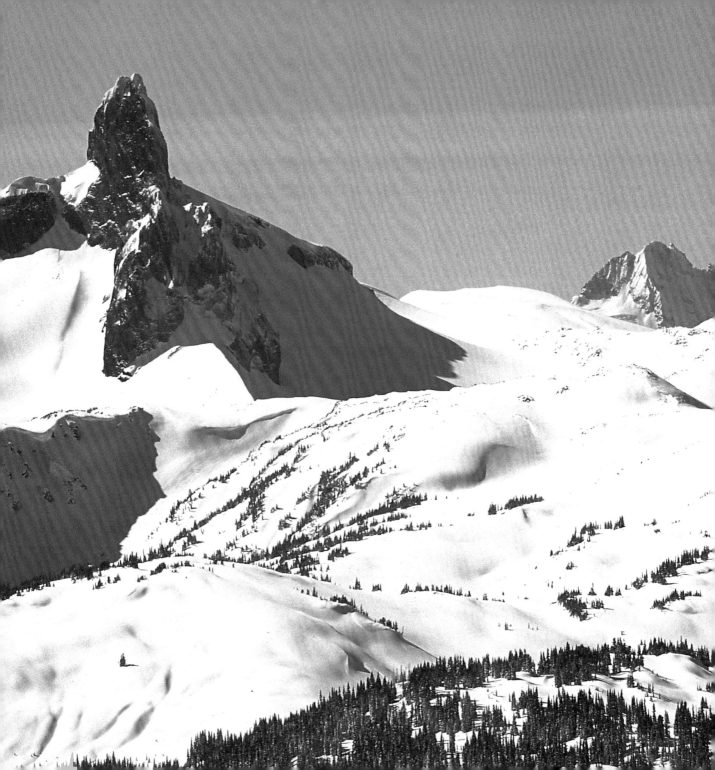

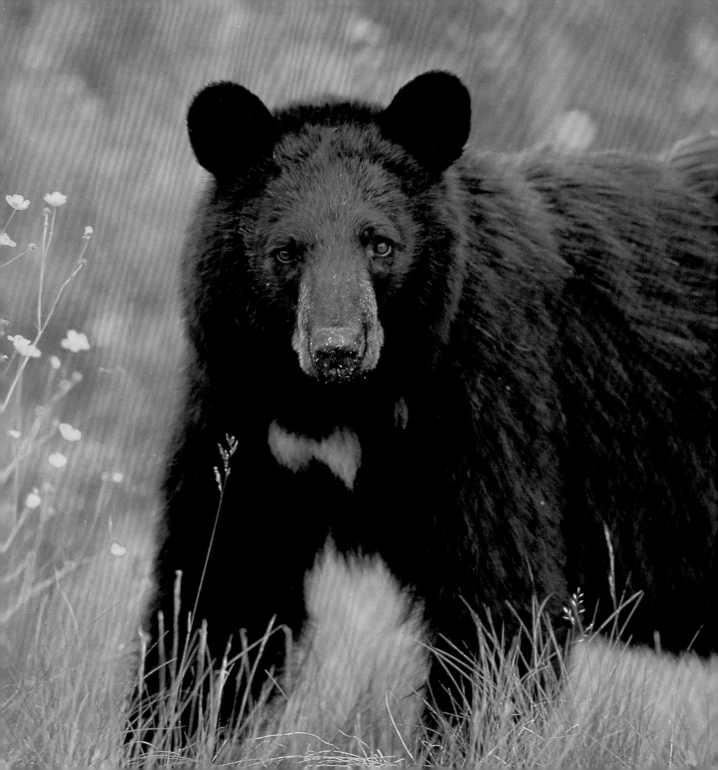

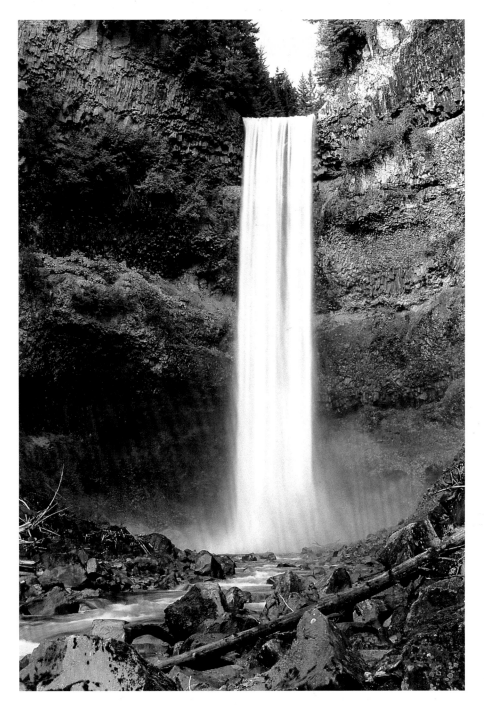

Brandywine Falls earned its name when surveyors Bob Mollison and Jack Nelson bet a bottle of brandy against one of wine over the height of the falls—66 metres.

FACING PAGE
Black bears cover a large territory, sometimes roaming from the alpine to the seashore in the space of a season.

PREVIOUS PAGE
According to First Nations legend, Black Tusk is home to the Thunderbird, who creates thunder and lightening from the peak. This lava plug tops an extinct volcano, and reaches 2,315 metres.

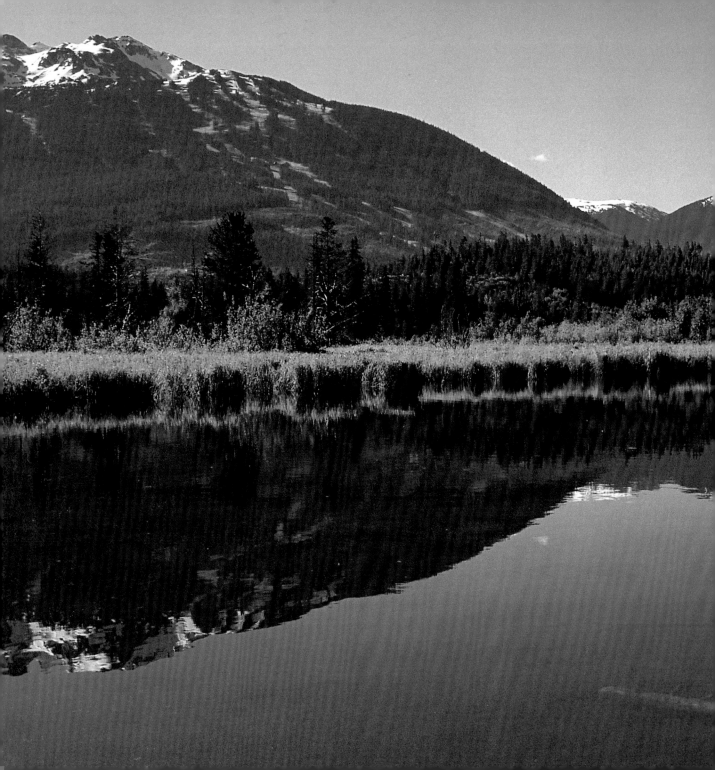

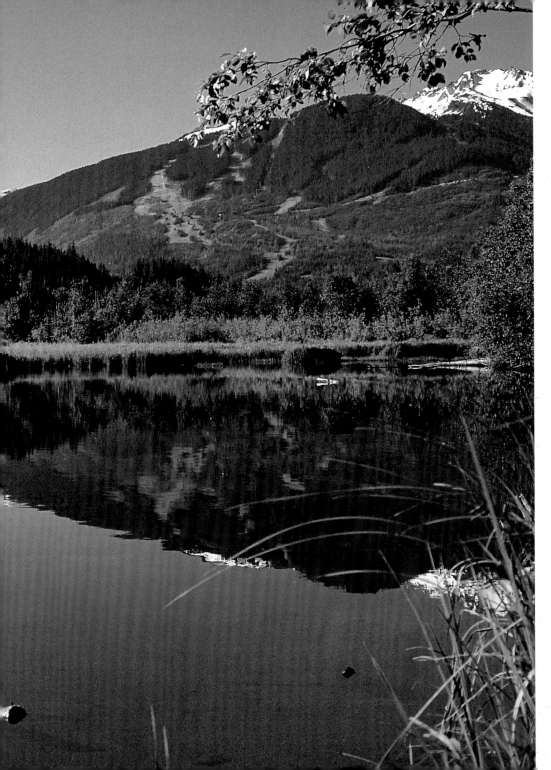

A tranquil beaver pond reflects the snow-capped peaks of Blackcomb and Whistler mountains.

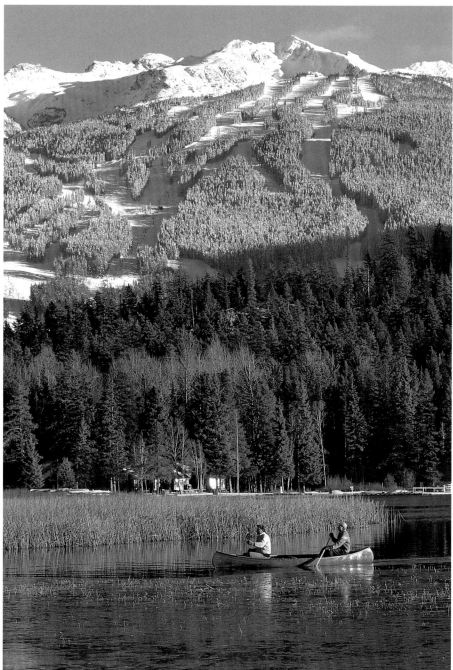

In the early 1900s, the route to Alta Lake involved a steamship, carts, and pack horses. Today, parks line the shores, paddlers enjoy the water, and in-line skaters glide by on the valley trails.

FACING PAGE
Forests of western hemlock, birch, alder, cottonwood, Douglas fir, and western red cedar form a colourful tapestry in Garibaldi Provincial Park. Most of this 195,000-hectare park is accessible only to hikers and cross-country skiers.

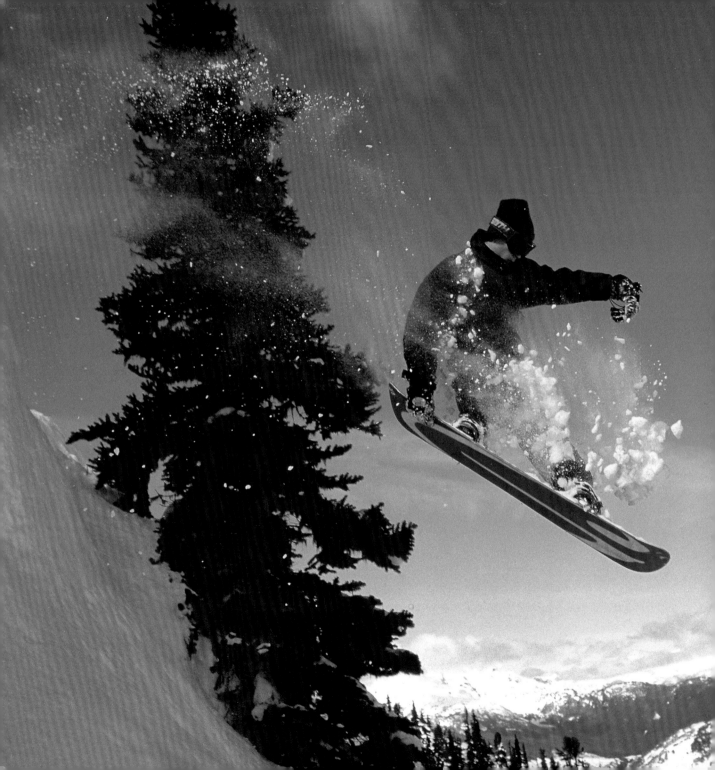

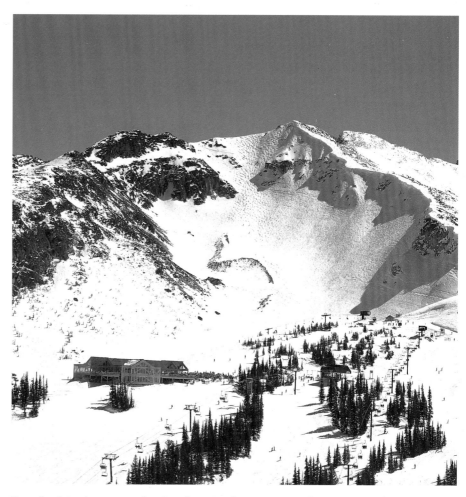

Breathtakingly steep, the Saudan Couloir was North America's first double black diamond run.

Traditionally, Whistler Mountain was the domain of skiers while snowboarders chose Blackcomb. With the booming popularity of snowboarding, however, boarders of all ages can now be found on both mountains.

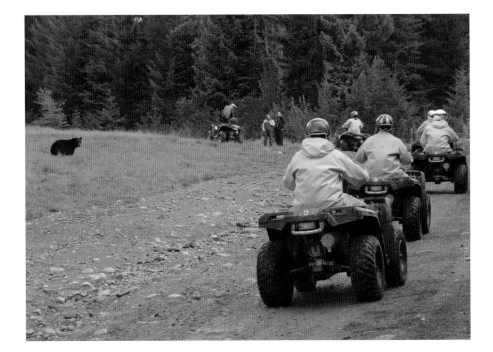

Visitors to Whistler seeking adrenaline-fuelled adventure can choose from a wide variety of activities, even after the regular ski season. Guided tours are available by helicopter, jet boat, whitewater raft, and ATV. Other popular activities to get the heart racing include glacier hikes, mountaineering lessons, and rap jumping.

For more relaxed outings, visitors can enjoy the alpine meadows and breathtaking mountain vistas. Whistler also offers massage services, heated hotel swimming pools, and even yoga and meditation classes.

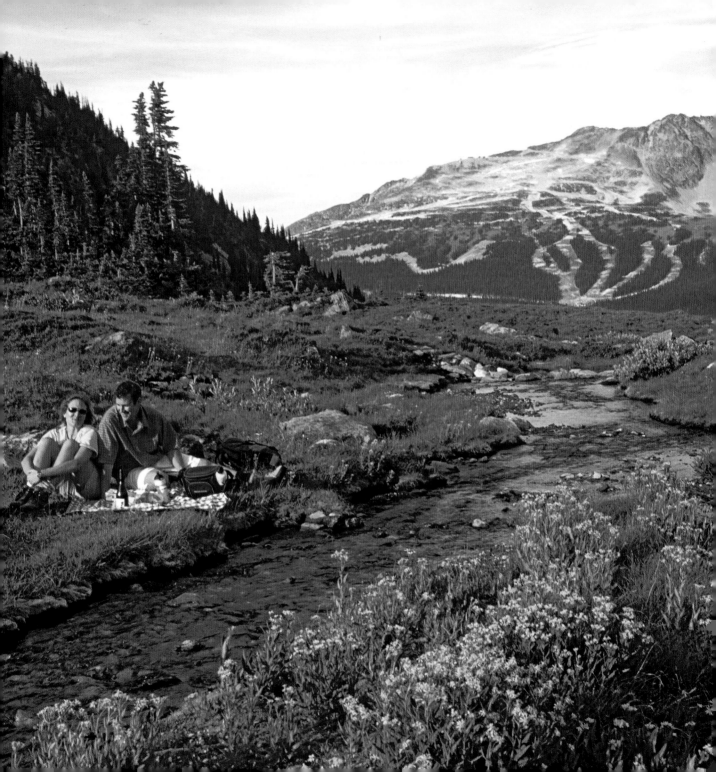

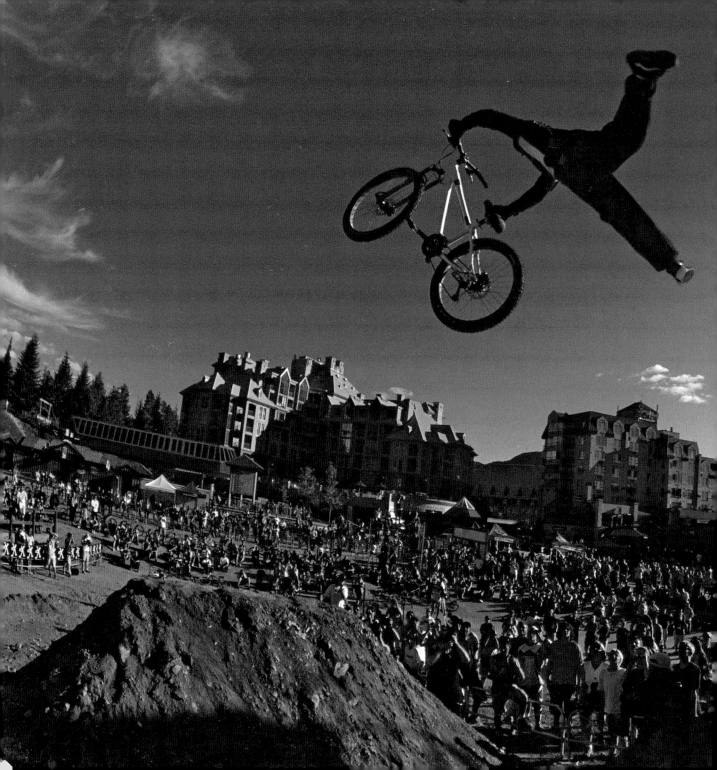

The spectacular scenery at Whistler provides an attractive location for annual events and festivals. The Whistler Film Festival takes place in early December, followed by the First Night celebrations each New Year's Eve. The Whistler Music and Arts Festival occurs in mid-July. Cornucopia, in November, is billed as Whistler's Wine and Food Celebration, and CrankWorx, shown here, is the town's annual mountain biking festival in August.

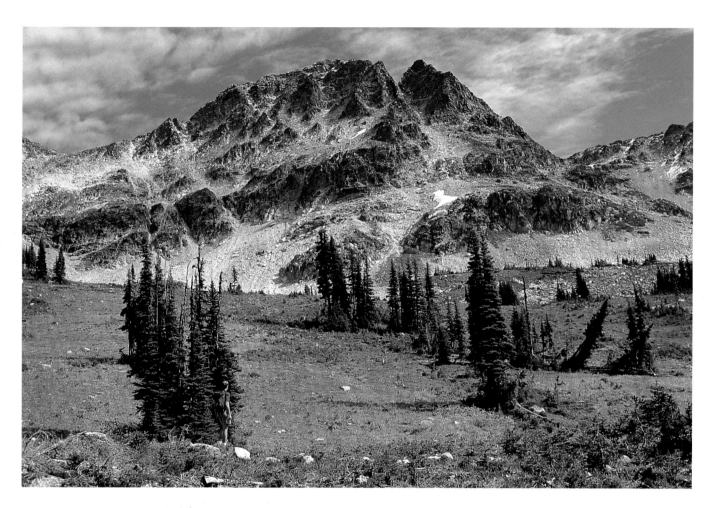

With the help of a few ski lifts, summer hikers can easily find themselves in alpine areas such as Xhiggy's Meadow, watching for deer, marmots, and wildflowers. The meadow was named for avalanche forecaster Peter Xhignesse.

In the early 1900s, a cabin on the shores of Green Lake was the home of early settler Charlie Chandler, who trapped throughout the area in the winters.

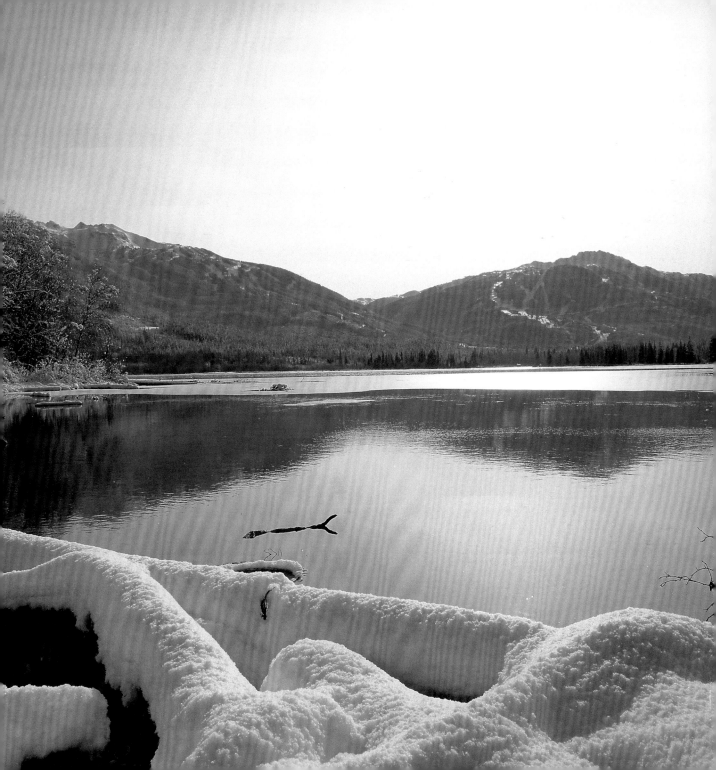

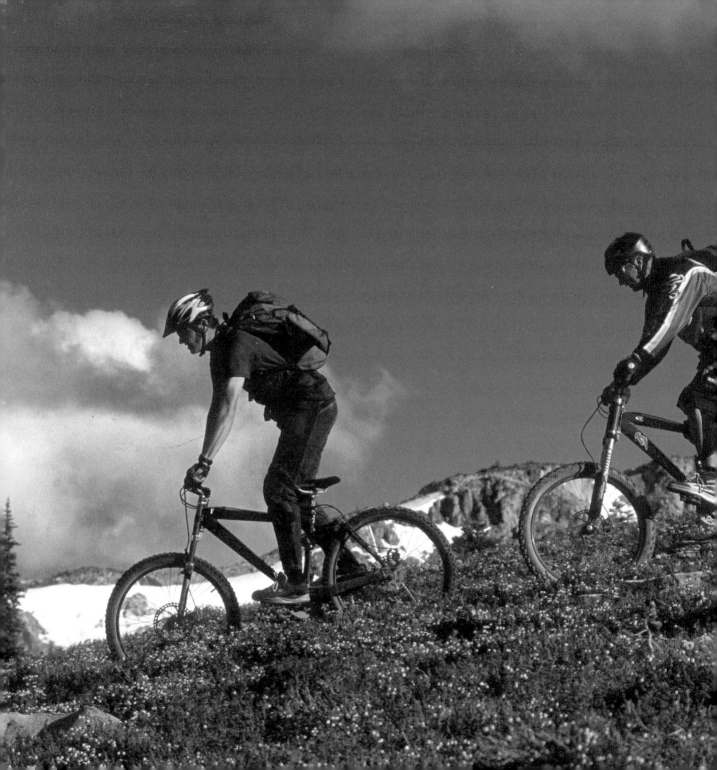

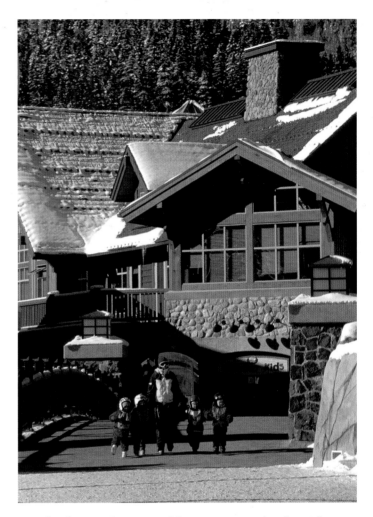

Creekside was the original base area at Whistler. After a four-year improvement period, the site has re-emerged as a quieter alternative to the main Village.

Whistler Village and the recently developed Creekside base area are joined by a network of user-friendly bike paths and surrounded by 20 kilometres of paved valley trails.

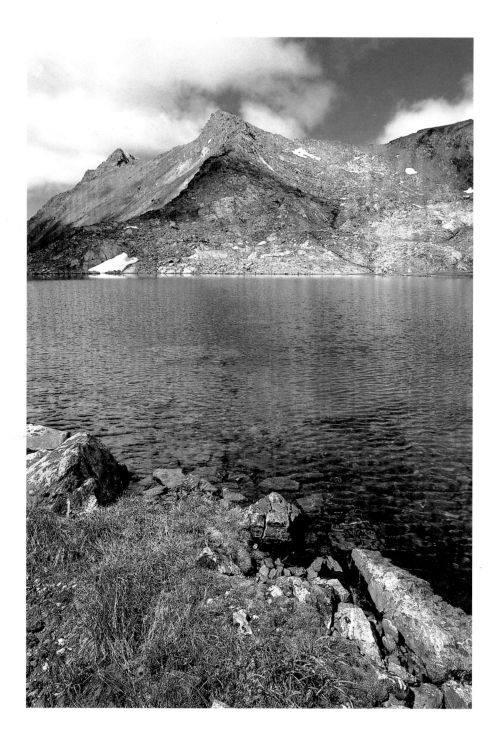

The icy blue of Upper Twin Lake sparkles in the afternoon sun.

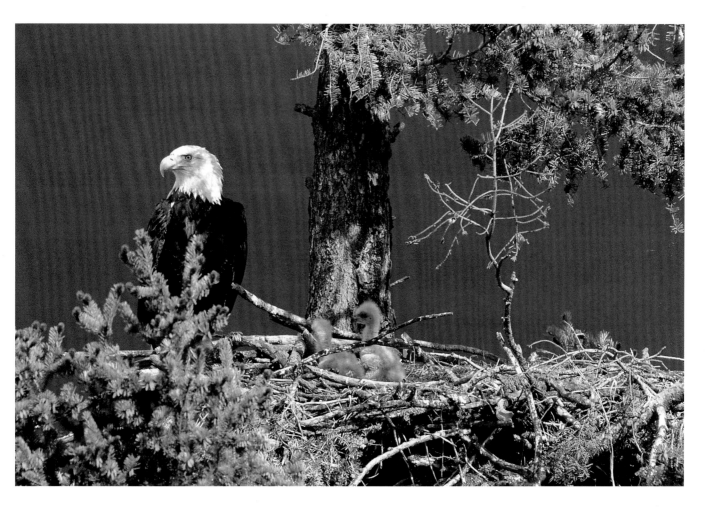

Bald eagles are a common sight near Whistler. In fact, Brackendale, just south of Whistler in the Squamish Valley, is one of the world's largest winter habitats for these majestic raptors.

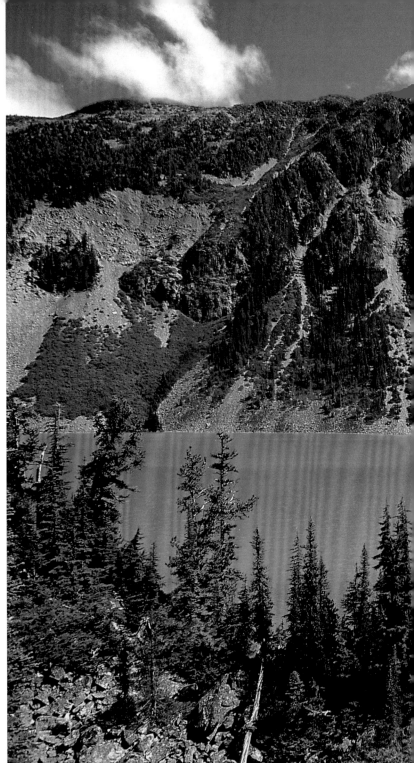

The three-hour hike to
Upper Joffre Lake begins
near Pemberton, north
of Whistler. Hikers are
rewarded with the crashing
of ice as Matier Glacier
feeds into the emerald lake.

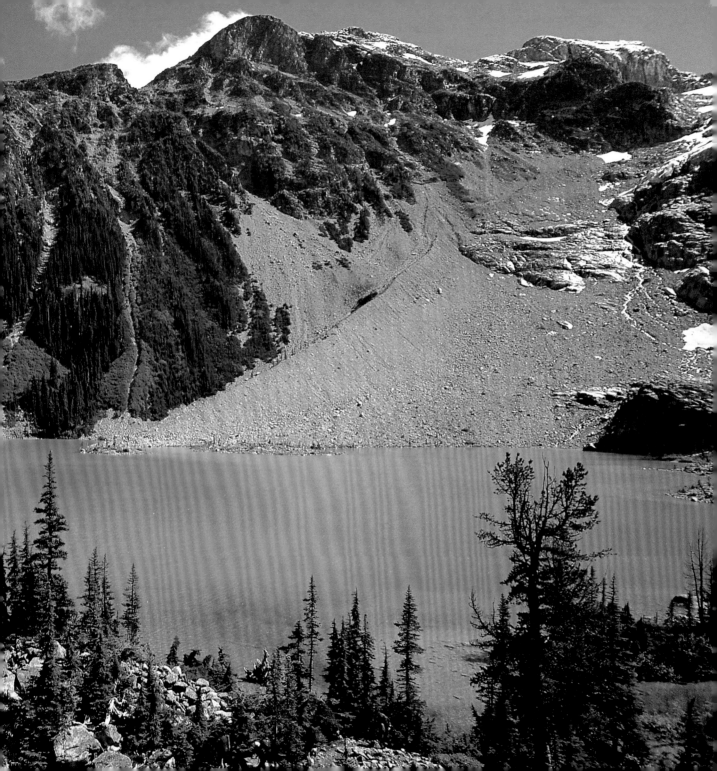

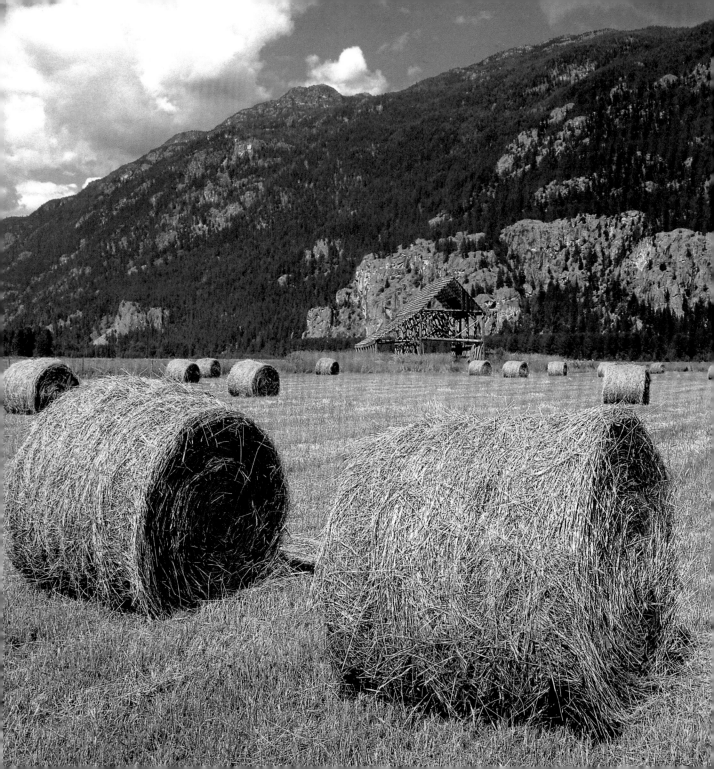

The agricultural areas surrounding Pemberton ensure a wealth of fresh produce for summer visitors.

FACING PAGE
The Pemberton Valley, northeast of Whistler, has strong roots in farming, ranching, and logging. Whistler's expansion has brought more people to the region and made Pemberton one of Canada's fastest-growing communities.

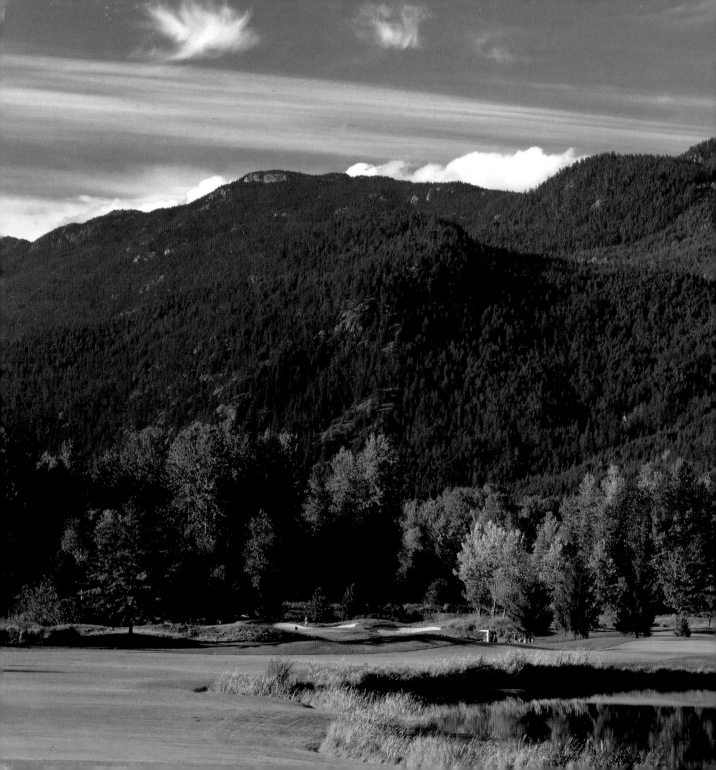

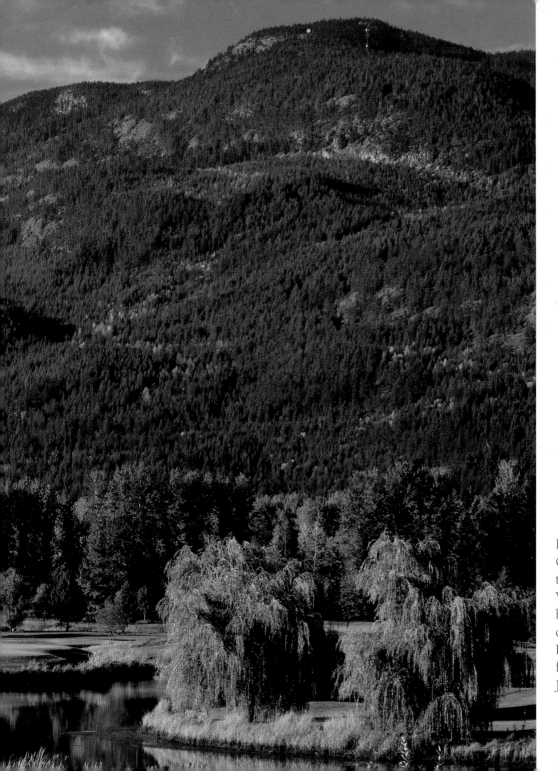

Big Sky Golf and Country Club in the Pemberton Valley was designed by award-winning course architect Robert Cupp, a former designer for Jack Nicklaus.

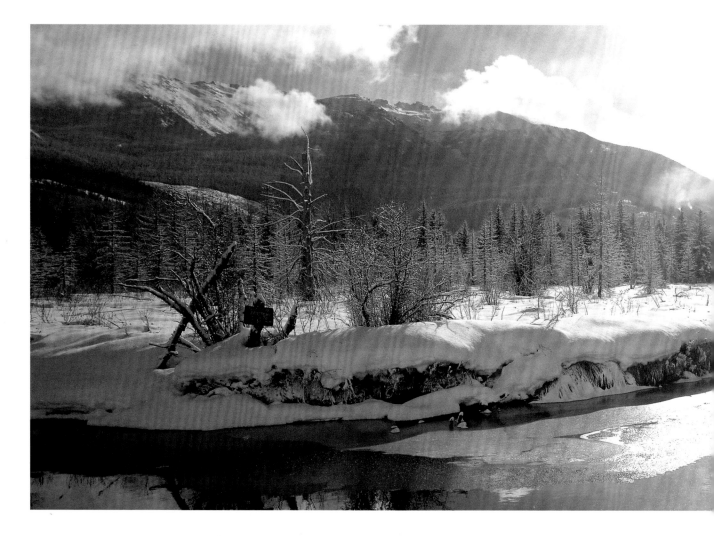

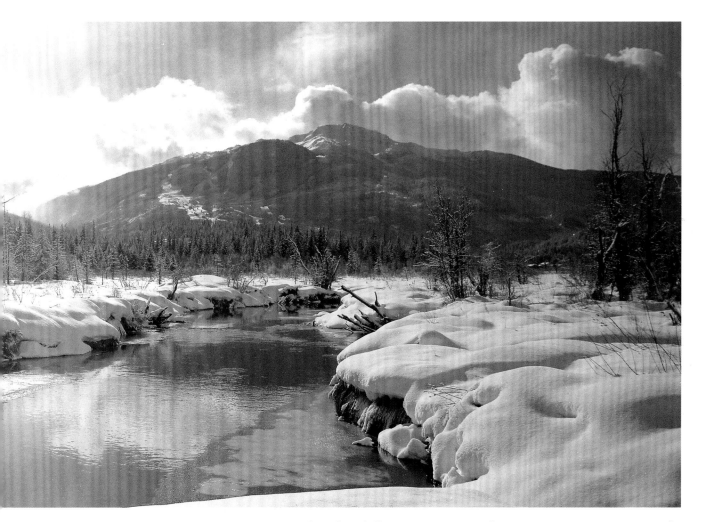

Contrary to what this chilly scene suggests, the Coast Mountains are part of a volcanic chain known as the "Rim of Fire," which circles the Pacific Rim.

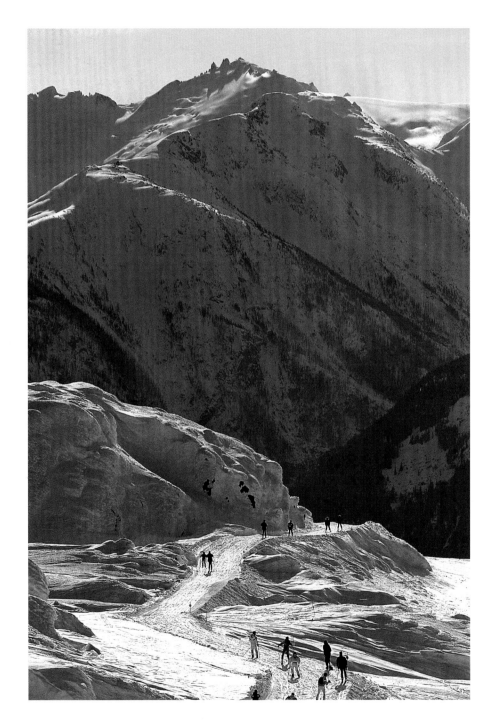

A mild average winter temperature of -4°C makes a long cross-country ski expedition an enjoyable way to spend a sunny afternoon.

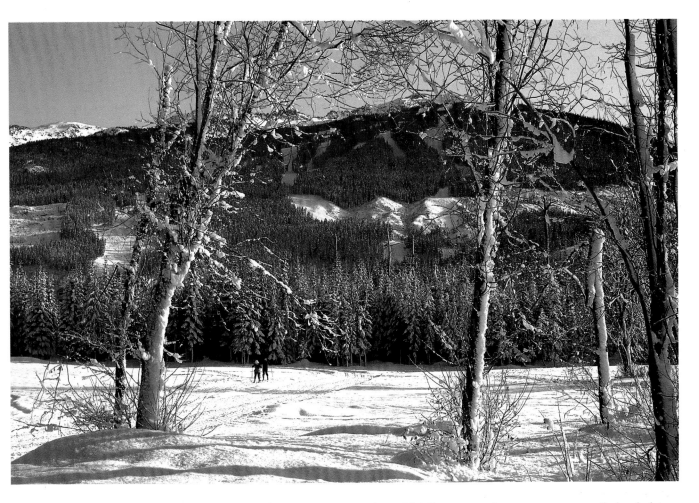

More than 30 kilometres of cross-country trails lead skiers around Lost Lake, the Chateau Whistler Golf Course, and the Nicklaus North Golf Course, shown here.

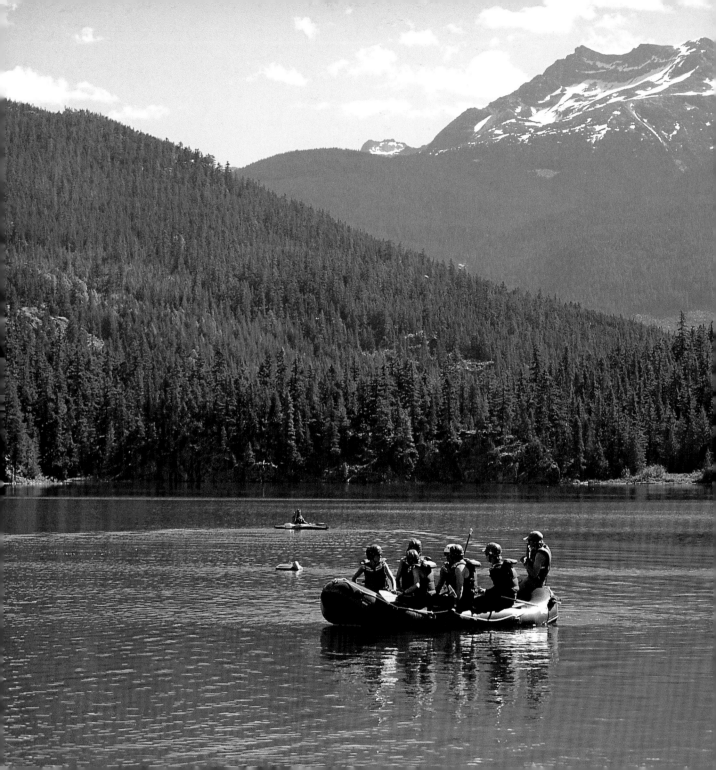

Visitors can choose a more serene rafting trip, or a journey through rapids with names such as Disaster, Steam Roller, and Devil's Elbow. On the Squamish, Mamquam, Green, or Cheakamus rivers, adventure is just a few bends away.

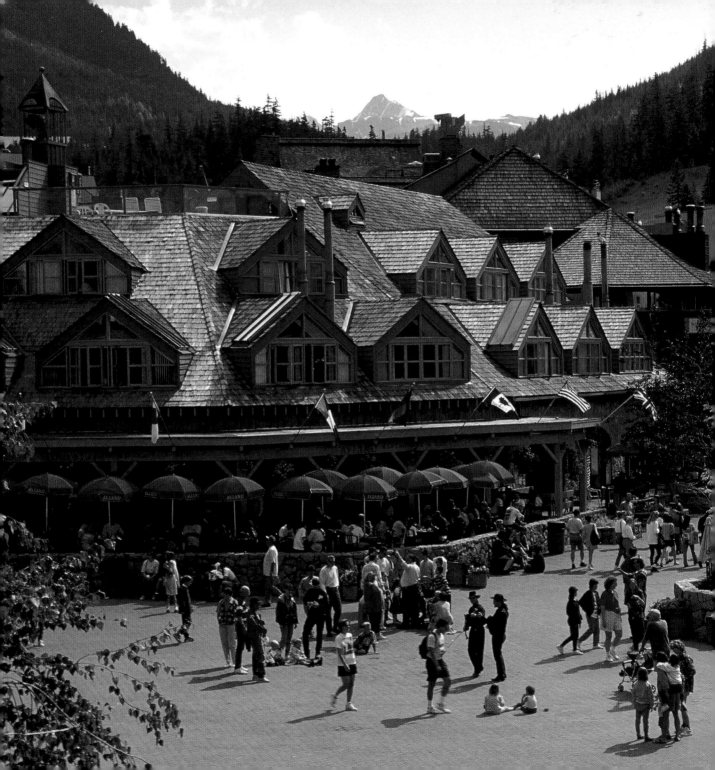

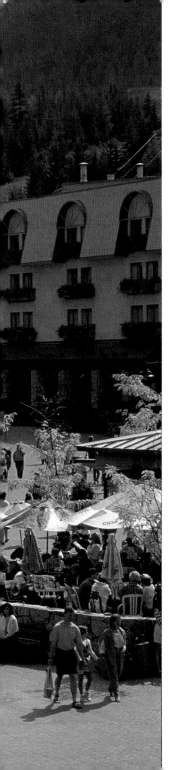

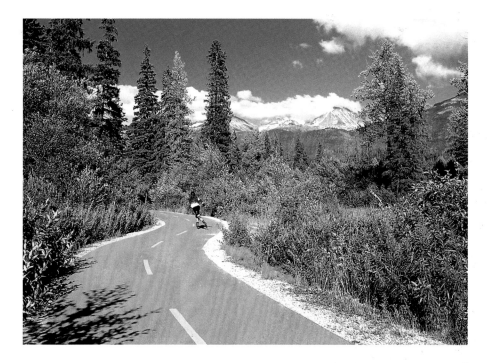

In-line skating is a popular summer activity, well suited to the paved valley trails that skirt the Whistler area.

Whistler Village has developed rapidly in just a few decades—it has had electricity only since 1964.

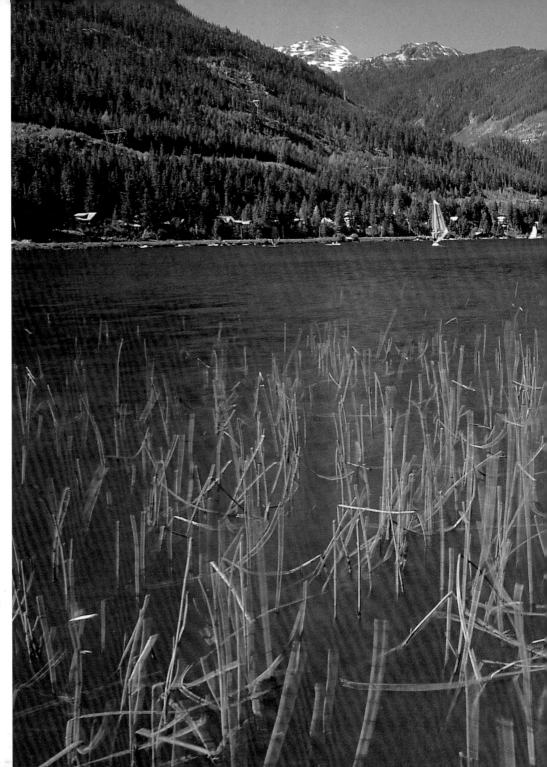

Alta Lake is the traditional boundary between the First Nations of the Squamish and Lillooet regions. Hudson's Bay Company explorers named it Summit Lake in the mid-1800s. The name was later changed to Alta, which means summit in Spanish.

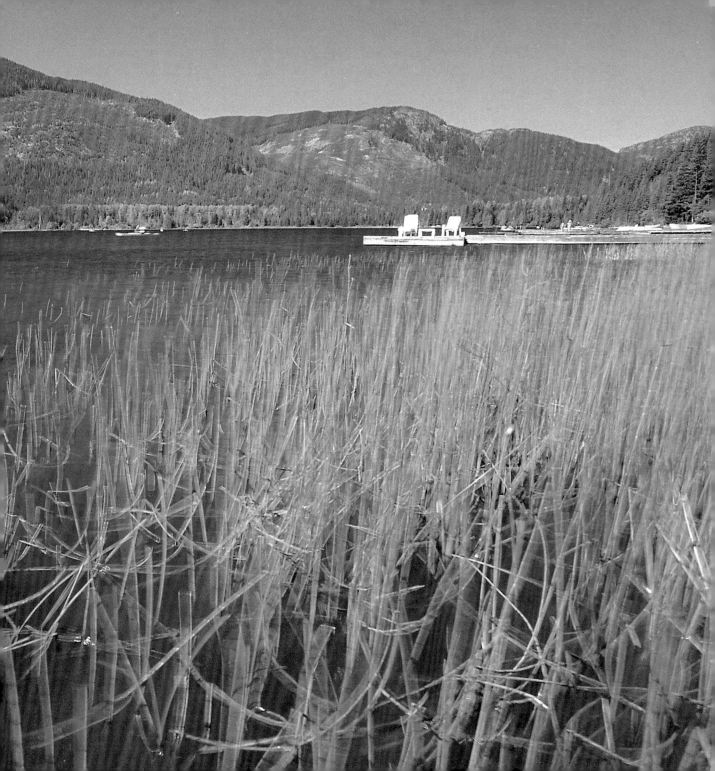

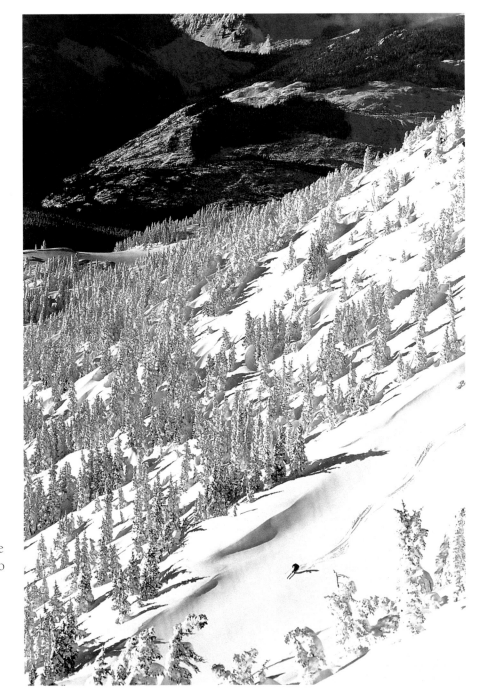

It has never been so easy to hit the slopes. The trip from Vancouver to Whistler was once a five-hour journey along a one-lane road. Now it's an easy two-hour drive. The lift ride from the base of Blackcomb to Rendezvous Lodge has dropped from forty-five minutes to fifteen, thanks to high-speed lifts.

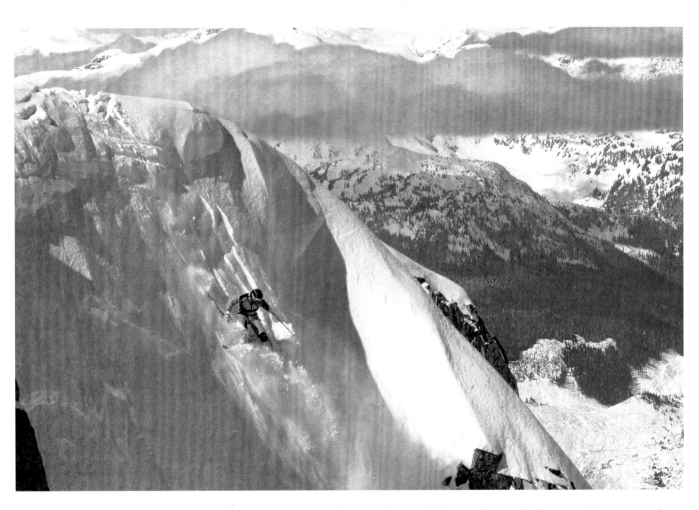

An experienced skier tackles a challenging drop, one of many that make this area a favourite with extreme skiing and snowboarding fans.

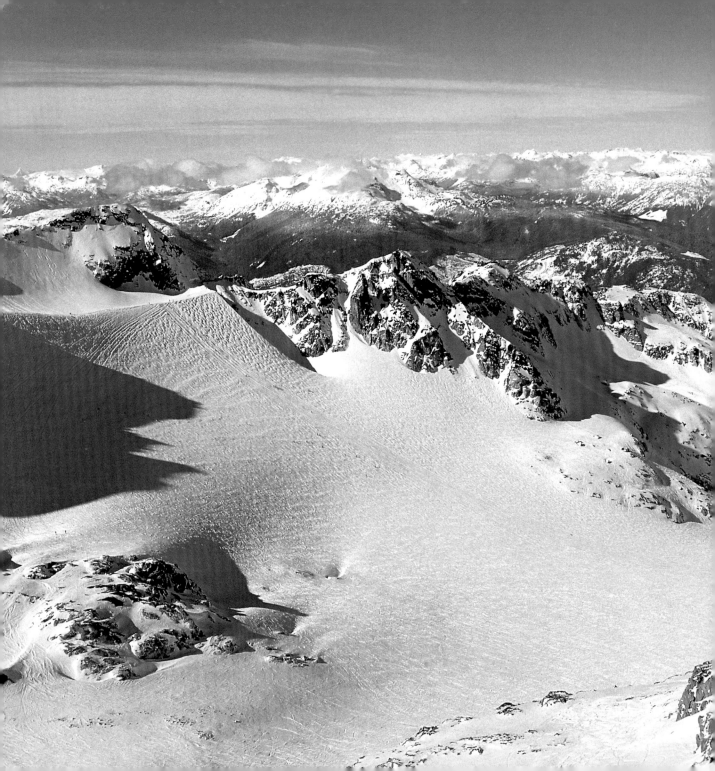

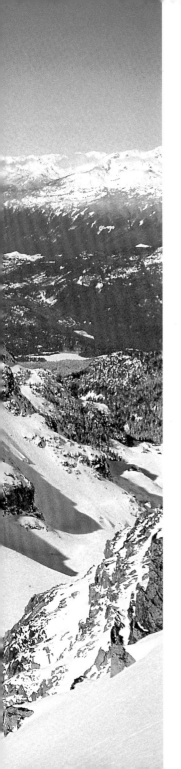

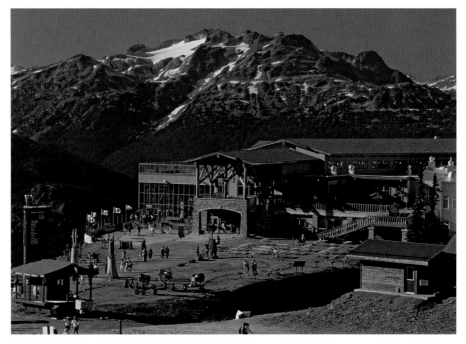

Intrawest, the company that owns Whistler/Blackcomb, owns resorts across North America, including Quebec's Tremblant, West Virginia's Snowshoe, and California's Mammoth.

Three lift-accessible glaciers are just part of the reason *Snow Country Magazine*, *Ski Magazine*, and *Skiing Magazine* have named this North America's top resort.

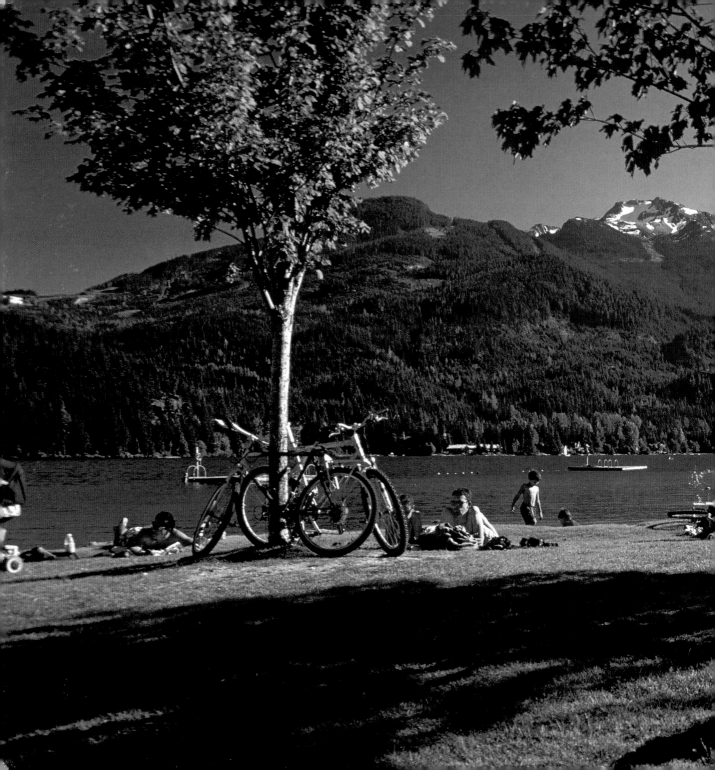

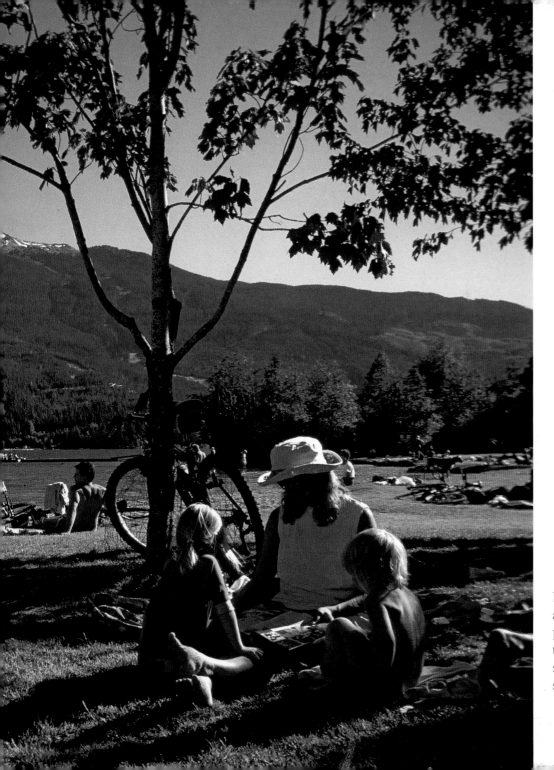

In summer, Alta Lake and its surrounding parks offer canoeing, tennis, volleyball, swimming, and sunbathing.

Photo Credits

GREG GRIFFITH / FIRST LIGHT 6–7, 8, 13, 16, 21, 32–33, 34, 36–37, 40–41, 53, 54–55, 58–59, 60, 61, 62, 63, 68, 69, 77, 80–81, 82, 83, 84–85, 90, 91, 92

RANDY LINKS / WWW.COASTPHOTO.COM 9, 12, 16, 38

BRAD KASSELMAN / WWW.COASTPHOTO.COM 10–11, 22, 23, 26–27, 39, 43, 50, 65, 86, 94–95

TREVOR BONDERUD / FIRST LIGHT 14–15, 42, 87, 88–89

RICHARD HARTMIER / FIRST LIGHT 17

D.C. LOWE / FIRST LIGHT 18, 20, 44–45

RON WATTS / FIRST LIGHT 19, 24, 51, 52, 74–75

BERND FUCHS / FIRST LIGHT 25

MAUREEN PROVENCAL 28, 48–49, 57

HILTON WHISTLER RESORT 29

ANDREW DORAN / WWW.COASTPHOTO.COM 30–31, 35

MICHAEL BURCH 46

JASON PUDDIFOOT / FIRST LIGHT 47, 72, 76

THOMAS KITCHIN / FIRST LIGHT 56, 73

JUSTA JESKOVA / WWW.COASTPHOTO.COM 64

RUSSELL DALBY / WWW.COASTPHOTO.COM 66–67

TYLER GARNHAM / WWW.COASTPHOTO.COM 70

SCOTT BRAMMER / WWW.COASTPHOTO.COM 71, 93

HENEBRY 78–79